IMAGES
of America

NEBRASKA
COURTHOUSES

CONTENTION, COMPROMISE, & COMMUNITY

Nebraska Counties

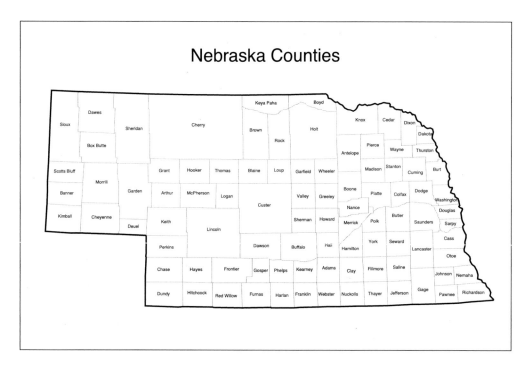

This book is dedicated to Burnice Fiedler.
Her thoughtful habits of collection,
knowledge about postcards, and
generosity assisted this book immeasurably.

The cover, a 1912 photograph, depicts the second Douglas County Courthouse in Omaha (in the foreground) built in 1882. Its Renaissance Revival-style replacement, designed by John Latenser, under construction from 1909 to 1912, is in the rear. This building continues to house most of the courts in Douglas County. A fourth structure, the 16-level Omaha-Douglas Civic Center, just to the west, opened in 1974. This image reveals the deceptiveness of a single image without another structure for comparison. Dramatic changes in architectural styles occurred between 1882 and 1909. Nebraskans built over 67 courthouses with towers between 1857 and 1907, but none after that date. Building on the same ground with temporary co-existence was common. Douglas County outgrew the 1882 structure, designed to accommodate a population of about 100,000. Not until the 1970s did developers, city planners, and landmark preservationists reconsider redevelopment and the wholesale destruction of pre-existing buildings. For other side-by-side views see Buffalo, Nance, Wheeler, and Burt Counties. (Courtesy of the Bostwick-Frohardt Collection, owned by KMTV, Durham Western Heritage Museum, Omaha, Nebraska.)

IMAGES
of America

NEBRASKA
COURTHOUSES

CONTENTION, COMPROMISE, & COMMUNITY

OLIVER B. POLLAK

ARCADIA

Published by Arcadia Publishing,
an imprint of Tempus Publishing, Inc.
3047 N. Lincoln Ave., Suite 410
Chicago, IL 60657

Printed in Great Britain.

Library of Congress Catalog Card Number: 2002102214.

For all general information contact Arcadia Publishing at:
Telephone 843-853-2070
Fax 843-853-0044
E-Mail sales@arcadiapublishing.com

For customer service and orders:
Toll-Free 1-888-313-2665

Visit us on the internet at http://www.arcadiapublishing.com

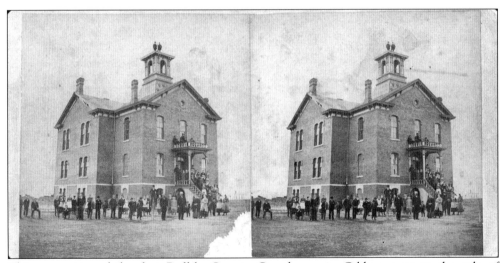

This stereoview of the first Buffalo County Courthouse in Gibbon suggests the role of courthouses in popular imagination. Charles Driscoll of Omaha designed this courthouse, built in 1872-73 from bricks made in Gibbon, at a cost of $16,000. The building opened on George Washington's Birthday, February 22, 1873. In 1874, Kearney won a county seat election and "stole the courthouse records." It survived as a Baptist Seminary, Gibbon College Institute, Gibbon Normal and Business College, and finally as part of the school system. The precipitating event causing Kearney's ascendancy was the joining of the Burlington and Missouri Railroad with the Union Pacific at Kearney Junction in 1872. (Courtesy Nebraska State Historical Society.)

CONTENTS

INTRODUCTION

The United States has about 3,066 counties; Nebraska has 93. The influential *Court Houses* (1978), containing 359 photographs of significant structures, completely ignored Nebraska. About 20 states, not including Nebraska, have books picturing their courthouses. This volume proposes to rectify both omissions.

At the dedication of the Cass County Courthouse in 1892 Judge Allen W. Field stated, "The county court house is above all other structures the people's building." The courthouse witnesses, records, and preserves the most joyous of life's events to the saddest and most distressing, from birth to death, to marriage and divorce.

The Courthouse houses the Register of Deeds, County Treasurer and Assessor, judge's chambers, jury room, a place for county commissioners or board to meet, election commissioner, marriage licenses and death certificates, vital statistics, storage of records, and often a jail or holding cell for prisoners awaiting their day in court. Aside from criminal indictment, trial, conviction and sentencing, other ominous courthouse activities included mortgage and tax foreclosure sales of homes and farms. Issues involving orphans, juvenile matters, guardianship, conservatorship, probate, and the coroner were also conducted inside the building.

Citizens, taxpayers, judges, lawyers, the sheriff, other law enforcement officers, and visitors from out of town frequented the county's official center. Eating lunch in the park and listening to music in the bandstand on Saturday nights were longstanding activities. Courthouses were used for every public purpose, including political meetings, home talent plays, school and entertainment, school examinations, social and church gatherings.

Each of Nebraska's 93 counties has a County and District Court that has civil and criminal jurisdictions. The county is part of a Nebraskan's identity. Automobile license plates until 2001, were prefixed by county identifying numerals - 1 through 93. Douglas County was 1, Lancaster 2, and Sarpy County, 59. Travelers driving the length of the state recorded license plates from Maine to Hawaii, from counties on the edge of the Missouri River to the Colorado border. County consciousness continues in 2002 with some license plates bearing the county name.

Cities, towns, and villages are known for their churches, city halls, post offices, hotels, YWCAs, libraries, train stations, banks and opera houses; at one time Nebraska had over 513 opera houses, one fourth are still standing, and 25 are on the National Register of Historic Places. It is the courthouse that provides the surest sign of accomplishment and stability, a central object of civic pride.

Territorial expansion and settlement resulted in the establishment of counties, county seats and courthouses. The history of law, order, government and bureaucracy focus on these structures, or to borrow a late 19th century expression, these "palaces of justice." The history of public architecture in Nebraska is seen in the styles architects applied and by comparing them to other buildings in different times and jurisdictions.

Construction, repair, and maintenance of these buildings tested creativity. Town boosters and railway companies might donate land and building costs. The electorate approved bonds and tax levies. State statute allowed inheritance taxes to be applied to courthouse capital expenses. Plans

ranged from frugal to grandiose. County, state and federal architecture, and construction are governed by time, cost, imitative style, and locale. First courthouses might be dugouts, log buildings, sod houses, or rented space, but they soon aspired to a greater presence. Sparse population and county tax base provided limits, such as Frontier County where Stockville's 1900 population of 269 declined to 32 by 2000. Omaha in Douglas County, at the other extreme, had greater population resources, rising from 102,555 in 1900 to 716,998 in the metropolitan area according to the 2000 census, and its needs are reflected in the impressive stature of the building. Woe to the town that lost a challenge to its county seat appointment, it could end up as a cemetery or ghost town. D.M. Ward has written, "that it was better for a town to never have had the county seat than to have had it and then to lose it." The buildings were not immune to the ravages of nature. Many structurally unsound towers were removed and fire left harrowing images of burned out hulks.

Building temples of democracy had time worn ceremonial aspects. The Masons were involved in courthouse activities and frequently met in the courthouse during the 18th and 19th centuries. They left their mark on the cornerstone well into the 20th century. The Grand Army of the Republic, Civil War Veterans, and the American Legion saw their military service contributing to a way of life and government. They appeared for dedications and filled the interior and exterior with monuments and plaques commemorating those who had given their all.

Many of the images contained in this book derive from postcards printed in Germany. An Albion, Nebraska, card contained the term "Postcard" in Italian, French, German, Spanish, Polish, Russian, Swedish, Czech, Portuguese, and Rumanian. The postcard of the courthouse in Kearney, published by The Omaha News Company, was printed in Germany.

In 1907, Hammond Printing of Fremont proclaimed in red ink, "THE LOCAL VIEW CARD IS A MONEY MAKER" and stated: "The demand is growing rapidly and you want to supply it or you are losing good dollars. An investment in a line of views of your own city will be the best proposition you ever had. All work done in our own shop in Fremont. Do not wait six or eight months for goods to be made in the 'old country.' We can have them in THREE WEEKS. Look into this today and send in your orders." Cards were also produced in Alliance, Blair, O'Neill, and Plattsmouth.

Cards contained messages. One apologized for not having written sooner, or for writing so little. Another recorded an "encounter with an awful storm." They commented on heat, drought, rain, and snow. This August 23, 1917 message explained why Emmett did not visit his sister—there had been a heavy rain and he did not want to get stuck in the mud. He adds plaintively, "So many of the Almena [Kansas] boys have to go to war. They sure feel bad about it." In May 1942, a card noted a flood in Lincoln and a tornado to the south that killed five. These writers traveled by horse, wagon, train, and car, voicing ageless expressions and sentiments, as in 1909: "Grand Island is a pretty little town. I like it all right not to live in." A son assured his mother that he ate well and washed his hair. Messages referred to marriage, health, trips to the dentist, sickness, recovery, death, working, accidents and injuries. Cards were written by attendees at the 1909 Nebraska Synod of the Foreign Missionary Society in Auburn, teachers at a 1910 conference in Alma, 1960 brotherhood lodge meetings in Hastings and in Minden, and various Chautauquas.

Rights of passage included congratulations on birthday and wedding anniversaries, and in 1908, writing from Hastings, "Dear Grandpa, I have passed the examination for the Navy. I have to start about Friday or Saturday for the training station. From your grandson, Elbert."

An Albion card contained the message, "This is our Court House. But we are going to have a new one [$]75,000 in the spring." On the back of the Cherry County view it stated, "Here is where Dad was County Judge, 11 years." A 1908 Ponca card contained the statement, "Came down here this morning to file cases." A Douglas County card from 1936 contained the message, "Dear voter: Thanking you for your support in previous elections and hoping that I have merited your continued support, I am, Gratefully yours, W.A. Day for District Judge." An early 20th-century postcard writer from Hastings exclaimed, "Is not this a beautiful building."

Some writers, perhaps postcard collectors, sought an exchange: "Here is our Clay County Court

House. I'm not so particular what kind of view card I receive in return." A collector responded with a postcard in 1910: "Received your court house and will return the compliment. What do you think of the Dodge County Courthouse?" Collectors created thematic postcard collections including courthouses, main streets, post offices, banks, opera houses, city halls, and universities.

Thomas Hart Benton painted *County Politics*, an iconic late 19th century Midwestern courthouse. Images of courthouse exteriors are preserved in over 10,000 postcards. Hundreds of films and television programs reveal the drama within. The county courthouse has been and will be the focus of both county business and those that seek to reveal its fluid image. United States Supreme Court Justice Lewis F. Powell Jr., wrote, "Public buildings often accurately reflect the beliefs, priority, and aspirations of a people." The county courthouse serves "not just as a local center of the law and government but as meeting ground, cultural hub, and social gathering place."

ACKNOWLEDGMENTS

I would like to thank Burnice Fiedler for permitting generous access to her wonderful postcard collection. The Nebraska State Historical Society and the National Register for Nebraska made it possible to build on the work of others. Kay Walters, of the University of Nebraska Newspaper Project, provided several 1990s courthouse photographs. Tom Heenan and Lynn Sullivan at Omaha's downtown W. Dale Clark Library, Les Valentine at the University of Nebraska at Omaha's Archives and Special Collections, the Douglas County Historical Society, Marshall Tofte of the Nebraska Association of County Officials, and the Bostwick-Frohardt Collection, owned by KMTV, at the Durham Western Heritage Museum, all assisted in making their valuable collections of Nebraska's visual images accessible. Many county historical societies, District and County Court Clerks, County Clerks, and librarians facilitated this project. Centennial volumes, local labors of love, were valuable. Architects and artists Leslie Iwai, Jayne Hutton and Martin Shukert provided valuable assistance on short notice. Thanks go to the editors at Arcadia Publishing for their receptiveness to my ideas. As always, the University of Nebraska at Omaha, where I have taught since 1974, provided continuing support. I have used the National Register for Nebraska definitions and descriptions of architectural styles.

My wife Karen serves as a patient arbiter in my pursuit of history, law, photography, and architecture. Space in this book and the surviving records does not allow a definitive representation of all Nebraska's courthouses. However, this study does comprise an almost complete architectural record. This account does not purport to be an inquiry into town planning. It does not ask what went on inside the courthouse or how the courthouse fits into the memories and the oral traditions of the citizens. Those questions, and many more, are left for future historical research.

One
TERRITORY TO
STATEHOOD

The Nebraska Territory, created in 1854 as part of the Kansas-Nebraska Act, had its capital in Omaha. The capital moved to Lincoln in 1867. According to a rough census, the original eight counties, Burt, Washington, Dodge, Douglas, Pierce, Forney, Cass, and Richardson, had a population of 2,732 Americans in 1854. At the time of statehood in 1867 settlement had increased to about 50,000. The ideal county was 24 x 24 miles. Defining boundaries, establishing and organizing the county might take several years. It should not be forgotten that Native Americans originally peopled this land. County seats moved as many as four times. In 1913, when Arthur County separated from McPherson County, Nebraska had 93 separate counties.

Olson and Naugle indicate that "Nebraska's transition from territorial status to statehood was more complicated than that of any other Louisiana Purchase state," and in great part because of the capital location controversy. Again, "almost every one of the thirty-one counties organized" from 1870 to 1873 "had a fight over location of the county seat." Some scars barely healed, with many towns still exhibiting resentment and a competitive spirit.

The State Supreme Court, a seven-member bench, is located in the State Capitol. Judges are appointed by the governor, and retain office pursuant to public review at an election to determine their "right to remain in office" every six years. They are not opposed by another candidate and do not campaign. Removal of a judge by this process is very rare. It happened for the first time in 1996 when Supreme Court Justice David Lanphier failed to get voter approval due to a hard-hitting campaign ostensibly based on two decisions he wrote. To facilitate decision-making in the face of a mounting Supreme Court caseload the unicameral legislature introduced an intermediate Appellate Court in 1991.

Courthouse and Jail Rock in the vicinity of Bridgeport, in Morrill County, were landmarks along the Oregon Trail. Artist and traveler Alfred Jacob Miller named it "Court House" in 1837. The identification of "Jail Rock" occurred in 1852. They soon became the popular names. They are a wonderment and landmark for travelers and tourists. Courthouse Rock was Pony Express Station No. 33 on the Pony Express Route established in 1860.

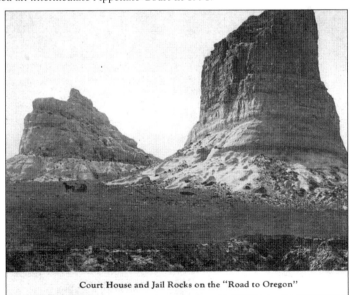

Court House and Jail Rocks on the "Road to Oregon"

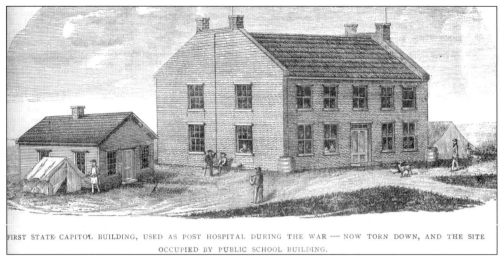

FIRST STATE CAPITOL BUILDING, USED AS POST HOSPITAL DURING THE WAR — NOW TORN DOWN, AND THE SITE OCCUPIED BY PUBLIC SCHOOL BUILDING.

Nebraska was established as a territory by the Kansas-Nebraska Act in 1854, with Omaha as the territorial capital. The first state capitol, located on Ninth Street between Farnam and Douglas Streets, was built in 1854. According to Luebke, the assembly met on the first floor, the council on the second. During the Civil War it served as a hospital and according to Dorothy D. Dustin in *Omaha & Douglas County, A Panoramic History* (1980) later housed the Union Pacific Railroad headquarters(1863–70), school classes, and church services.

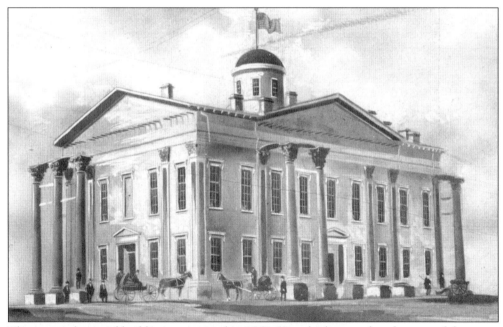

This more substantial building was erected in 1857-58 on high ground to the west of the town, at a cost of $130,000. Political interests were divided by the Platte River. Territorial Governor Thomas Cuming favored legislative districts north of the Platte and the capital in Omaha. Those south of the Platte wanted the capital anywhere but Omaha. Omaha lost the capital to Lincoln. A sketch in *Leslie's* on June 4, 1859, erroneously identified it as "the Omaha courthouse." According to Dustin it hosted parties and dances and the basement held a saloon. Razed in 1870, Omaha High School and Central High School were later built on this site.

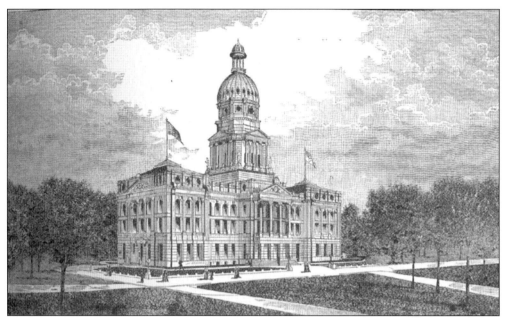

Skepticism greeted the choice of Lincoln as state capitol. Olson and Naugle observed that it "showed little promise as a city" and quoted a source declaring it "destined for isolation and ultimate oblivion." The first state capitol in Lincoln, a "mail order design," by Chicago architect James Morris, opened on December 1, 1868. The building cost nearly twice the $40,000 appropriation, funded in part by the sale of lots donated to the state. Built of limestone quarried near Beatrice, it soon began to crumble because of poor design and construction.

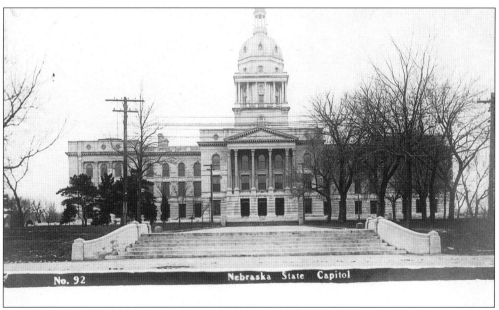

The second State capitol, designed by B.H. Wilcox of Chicago in 1879, and completed in 1888, sits on the same ground as the first. The outer parts of this building were built around the original structure. Only the statue of Abraham Lincoln, by prominent American sculptor Daniel Chester French, survived the move.

11

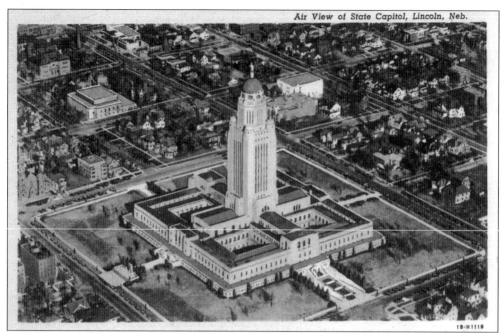

The current State Capitol, designed in 1920 by Bertram G. Goodhue, houses the Unicameral, a single house legislature (as inspired by George Norris), and the State Supreme Court. Inscriptions of the county names encircle the building. Restoration of the exterior masonry started in 2000. It is one of the most striking pieces of architecture in America. It is topped by the Sower. It stands at the southern end of Centennial Mall; the northern end houses the Nebraska State Historical Society.

This postcard of downtown Grand Island is titled "Grand Island and capital." In the center background stands a large building with a dome. This card combines wishful thinking and political aspirations to move the capital to Grand Island, Kearney, or North Platte, a subject debated in the mid-1870s and 1908–1910. (Information courtesy of Stuhr Museum of the Prairie Pioneer.)

Two

PAPER TOWNS, GHOST COUNTIES, & COURTHOUSE WARS

Eleazer Wakely, judge for the Third Judicial District, 1857–1861, convened court in courtrooms "improvised from halls, school houses, store rooms, or abandoned buildings" in Washington, Burt, and Dakota counties. Travel was by horse and buggy, and overnight accommodations were scarce in the early days. Judges often had to rely on the kindness of local lawyers. Courthouses were built very soon after settlement. This chapter covers most of the courthouses in towns that are no longer county seats.

The interplay of nature, aspiration, "boosterism," and reality can be seen in Nebraska's "paper towns and counties." H.W. Foght observed in 1906, "In those early days towns were projected rather promiscuously on the virgin prairie by ambitious organizers. Natural demand had little to do with such enterprises, the idea was to *make* a demand." The competition between towns for the position of county seat involved personalities, population density, and profits. Being the county seat was a positive asset. The struggle often got heated. Relocation of a county seat required three-fifths of the total vote.

Reports of fixed elections, fights, and county records transferred under armed guard fill the histories of Adams, Clay, Hamilton, Harlan, Hitchcock, Red Willow, Saline, and Washington Counties, perpetuating suspicion and resentment to the present day. One observer of a 1890–96 struggle between Indianola and McCook recorded, in 1927, "The historian of the future may, if he desires dig into the voluminous records which chronicle that historic contest, write a detailed account of a two-town fight that lasted six years, cost much time and money, shattered friendships and created contempt and hatred that nothing but time could ever cure."

Ward calculated that the 39 counties experiencing county seat relocation had a total of 91 different county seats. Twenty-three of these towns had ceased to exist by 1930. Schellenberg found that "matters of local pride, conflicts between leading personalities, pressure of economic interests, and governmental arrangements" were frequently at the heart of grass roots democracy and the county seat wars. The last county seat changed in 1929.

The Territorial Legislature split Sarpy County from Douglas County in 1857. Bellevue desired the territorial capital, but Territorial Governor Cuming chose Omaha. Bellevue, the original Sarpy County seat, houses Nebraska's oldest standing courthouse, and probably oldest business establishment. Built in 1855, it housed the Fontenelle Bank that soon failed. The county purchased it in 1856 for $1,500. It served as the Courthouse and then as Bellevue City Hall.

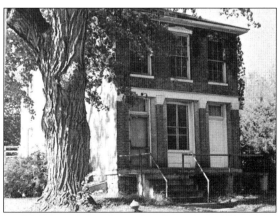

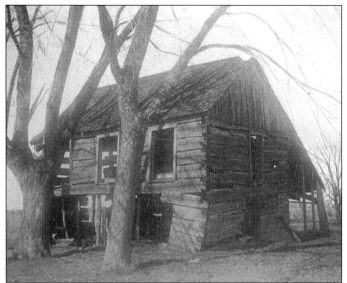

Washington County boundaries were defined by the legislature in early 1855. During the 1850s, the county seat moved from Fort Calhoun to De Soto and back to Fort Calhoun. It has been in Blair since winning an 1869 election. It is reported that one died in this county seat war. This De Soto building, seen in disrepair, was built "by popular subscription in 1856." It was constructed of logs and cottonwood boards, and was where court met in 1859.

Nemaha County, formerly part of extinct Forney County, was created in 1855. According to Dorothy Broady citing A.T. Andreas, this 18x18 ft., 1856 log building in Brownville served as courthouse, church and school where "judges ladled out law." The court moved in 1867 into its own 25 x 80 ft. building. Sheridan challenged Brownville, but ultimately the county seat went in 1883 to Auburn. The railroad fostering inland settlement replaced river transport.

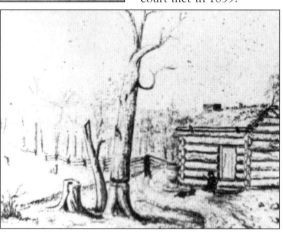

Saunders County, originally called Calhoun County, was established in 1856. Ashland, which had been in Cass County, became the county seat of Saunders County until defeated by Wahoo in a hotly contested 1873 election. This is the courthouse in Ashland, built in 1870. Dr. Von Mansfelde remodeled the courthouse into an emergency hospital and his residence. (Courtesy Saunders County Historical Society.)

Saline County was organized in 1867. County seat Swan City lost an election to Pleasant Hill in 1871, which lost an election to Wilber in 1877. According to Ward, the county seat was upset by the arrival of the railroad in DeWitt. Other towns that vied for county seat were Dorchester, Friend, Center, and Crete. This is the courthouse in Pleasant Hill, painted by Jack Tobias. (Courtesy Nebraska State Historical Society.)

Greeley County was formed by the legislature in 1871 and organized in 1872. Lamartine lost an 1873 county seat election to Scotia, where a 12 x 20 ft. courthouse, built in 1875, doubled as a schoolhouse. This larger structure replaced it. Scotia, described as "a straggling, haphazard village," lost an 1890 election to Greeley. The building served in the 1890s as the Scotia Normal and Business College and later as The Ben Hur Hall. (Courtesy Nebraska State Historical Society.)

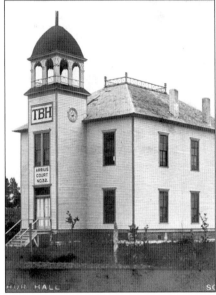

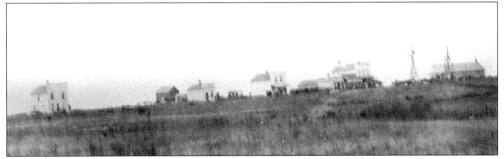

Phelps County was approved in 1873. Williamsburg and Phelps Center were early county seats. Sacramento also vied for the position. A courthouse built in 1879-80 moved from Williamsburg to Phelps Center, but a fire soon consumed it. This 1870s photograph depicts a typical emergent town containing, from left to right, the courthouse, two law offices, drug store, grocery, windmill, and hardware store. Nearly all were moved nine miles after the 1883 change to Holdrege, which was served by the Burlington Railroad. (Courtesy Nebraska State Historical Society.)

Holt County was established in 1862. Perkey states that Paddock superseded Twin Lakes as county seat in 1876. This log cabin, the first courthouse, was probably located in Paddock, originally called Troy. O'Neill defeated Paddock for the county seat in November 1879. For another view see Nellie Snyder Yost, *Before Today* (1976). (Courtesy Nebraska Historical Society.)

First courthouse in Holt County.

Wayne County was organized in 1870. Taffe, the first county seat, fell to La Porte where a brick courthouse replaced a frame structure in 1874. La Porte lost a bitter 1882 election to Wayne. Some La Porte buildings were dismantled and transported to Wayne. The 1874 building, like the Gandy courthouse, became a poor farm. This 8-foot square cupola, tended by a 4-H Club in the 1930s, survived the 1874 courthouse, but was dismantled in 1922.

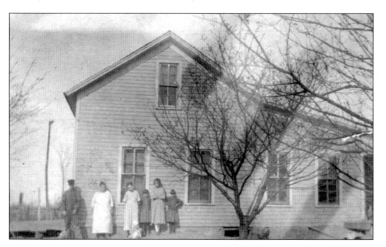

Hamilton County boundaries were defined in 1867. According to the *Centennial History of Hamilton County* (1967) this courthouse, built in Orville City in the early 1870s, may have been the first building in the town. By 1873, there were three grocery and general merchandise stores, a drug store, hotel, blacksmith shop, law and real estate offices, and a saloon. When Aurora won the county seat in 1876, they transported this building to Aurora. (Courtesy of Plainsman Museum.)

16

Custer County was established in 1877. The county seat is Broken Bow. This two-room, L-shaped cedar log cabin courthouse built in 1876, is near Callaway and is on display in Pioneer Park. Another view of this courthouse appears in pioneer photographer Solomon D. Butcher's *Pioneer History of Custer County* (1901). Jefferson in Custer County is named for the first postmaster, Thomas Jefferson Butcher, father of photographer Solomon D. Butcher. (Courtesy Marshall Tofte and Nebraska Association of County Officials.)

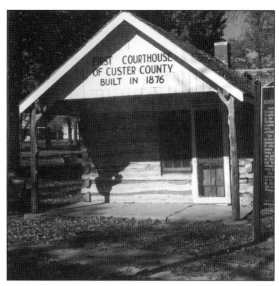

Knox County, initially organized as L'Eau Qui County in 1857, changed its name to Knox County in 1873. Niobrara served as county seat from 1857 to 1902, when Center assumed that position. This picture from the 1930s contains the two-story brick courthouse on Main Street in Niobrara. (Courtesy of Jane Graff and *Nebraska, Our Towns.*)

Red Willow County, established in 1873, had Indianola as the county seat. This brick courthouse, built in 1881, replaced the original frame structure. After the shift of the county seat to McCook, the top story was removed and the bricks were used to build a home directly east of it.

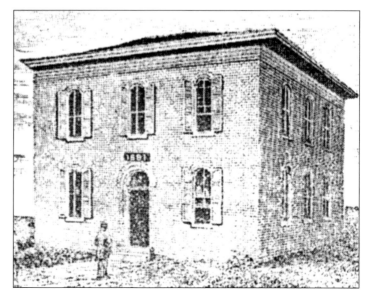

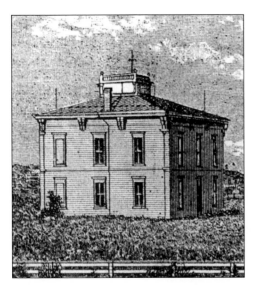

Franklin County was established in 1867 and organized in 1871. The first county seat, Bloomington, prevailed over Waterloo, a paper town, and Franklin City. This courthouse, erected in 1878, described as a "large and fine appearing structure … pleasant and roomy," survived the two fires that ravaged buildings around the square in August and November 1887. The surrounding park hosted the summer Chautauqua. Bloomington lost the county seat to Franklin in 1920 and its population declined. (Courtesy Nebraska State Historical Society.)

Hitchcock County organized in 1873 with Culbertson, on the Republican River, as the first county seat. It lost that position in a long and bitter contest to Trenton in an 1894 election. This is the courthouse in Culbertson ,built in 1886. Trentonites hauled away the records on lumber wagons on the night of October 1, 1893. The building became a school and burned in October 1903. (Courtesy of Jane Graff and *Nebraska, Our Towns*.)

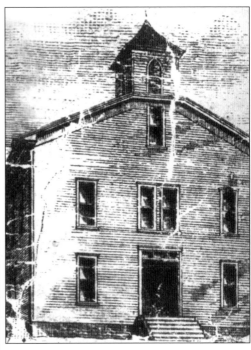

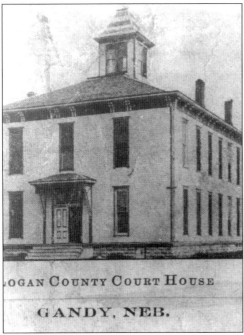

The Legislature established Logan County in 1885 with Logan as the county seat for 50 days. The Gandy's of Broken Bow promised to build a courthouse if they named the town for him. Gandy defeated Logan, 69 votes to 51, in an 1885 election. Built in 1887, the courthouse was rented out as a dancehall for $3 to $10 per night. The railroad bypassed Gandy and the county seat moved 3.5 miles in 1929 to Stapleton. The Gandy courthouse shared the fate of La Porte in Wayne County; it became the county poor farm.

Three
THE AGE OF TOWERS
1855–1907

Courthouse building in Nebraska begins with the initial accommodation of the county business, frequently rudimentary and temporary structures, and reaches a crescendo between 1864 and 1907, with the construction of over 110 courthouses, 67 of them having towers, some flamboyant and unsound. As late as the 1890s, a judge noted that he held court in a room, perhaps 14 x 20 ft., occupied between times by some county officer. Construction types included sod houses, log cabins, wood frame structures, and more durable brick and stone structures. They balanced economy, utility, civic pride, and grandeur. Public officials and designers could not anticipate the growth of the population or the growth of government. Citizen donations, voter approved bonds, and tax levies provided funding. Several courthouses were destroyed by fire; many were torn down and replaced by larger more durable structures.

The technology of expansion along the frontier changed dramatically going from rivers and trails to railroads. The early courthouses in eastern Nebraska were built before the arrival of the railway and frequently occupied the center of town–the courthouse block. Luebke has noted that as western Nebraska was settled, and counties formed, the railroad had already arrived and the courthouse was put on the edge of town. The train station had displaced the courthouse square as the center of activity. The railroad was constructed across Nebraska, east to west. The Union Pacific arrived in Nebraska in 1865 and the Burlington and Missouri River Railroad in 1869. Branches radiated north and south. Ward calculates that the railroad was important in the establishment of 36 county seats.

This chapter introduces The Romanesque Revival, Richardsonian Romanesque revival, and County Capitol architectural styles.

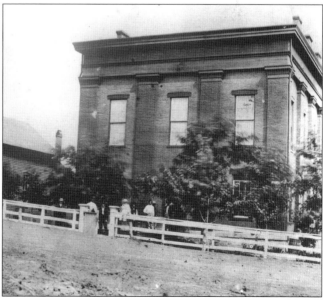

Douglas County was formed in 1854. The Douglas County Courthouse in Omaha on Washington Square, was bounded by Fifteenth, Farnam, Sixteenth, and Douglas Streets. Construction started in 1857. The basement of this two-story brick 50 x 70 ft. building served as a jail. A separate $35,000 two-story jail opened in 1879. This 1876 photo includes the sheriff's house on the left. (Courtesy of Bostwick-Frohardt Collection, owned by KMTV, at Durham Western Heritage Museum, Omaha, Nebraska.)

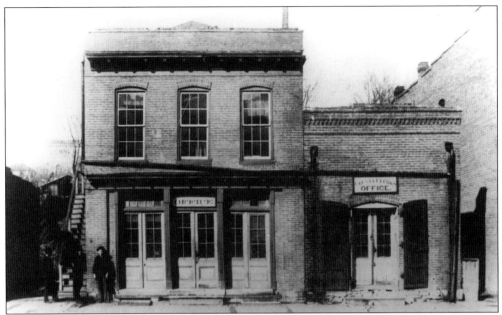

Cass County was established in 1855, with the county seat in Plattsmouth, where the Platte River joined the Missouri. The courthouse sat in five other structures before this specifically built courthouse opened in 1862. The wing on the right was added later. The second floor doubled to host lodge sessions, church services, receptions, parties, teas, and discussion clubs. This courthouse served until 1891. (Courtesy Cass County Historical Society.)

Otoe County was established in 1855. Table Creek changed its name to Nebraska City in 1855 and became the county seat. A log cabin housed the first term of District Court. In August 1864, $22,500 was voted for the courthouse. A.G. Basset, architect, received $150 for the plans. This Georgian-style structure, opened in 1864, is the oldest public building still in use in Nebraska. It has been the unfortunate scene of a lynching. The west wing was added in 1882. The building was completely remodeled and an east wing added in 1936-37 at the cost of $60,000. The building received an elevator in the 1990s. The postcard notes, "Mother and Dad were married in this Courthouse."

Dodge County was one of the original counties created in 1854. Fontanelle served as county seat from 1855 to 1860 when revised county lines placed it in Washington County. Fremont prevailed over Robbinsville and Blacksmith's Point in an 1860 election. A fire and a windstorm in 1884 severely damaged this first courthouse, a two-story brick structure built by John Ray for $4,950 in 1867. On December 31, 1887, fire destroyed part of the building and records.

This is Otoe County Courthouse in Nebraska City as it appeared in 1867. The photograph is attributed to Dr. F. Renner. The interior contains a large mural by Frank J. Zimmerer depicting the steam side paddle riverboats *Post Boy* and *Sioux*.

The boundaries of Pawnee County were defined in 1855. The county seat was in Pawnee City. A two-mill levy provided for the first courthouse, but in 1860 a severe windstorm leveled the incomplete frame structure. In 1868, $15,000 was voted for this 40 x 60 ft. building. According to John Brenneman, while it contained very fine white limestone, the failure to consult an architect resulted in "very faulty construction." It served until 1911.

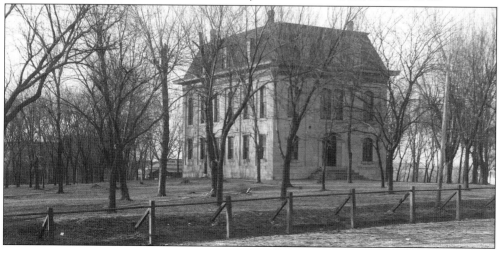

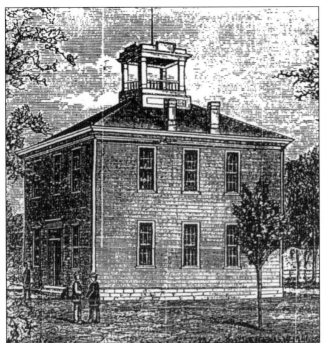

The boundaries of Johnson County were defined by the Legislature in 1855. Tecumseh became the county seat in 1857, with the first courthouse probably "merely" a 12 x 14 or 16-foot "frame shack." This "magnificent" building, built in 1868 for $2,600, replaced the court held in a schoolhouse. By 1888, the *Tecumseh Chieftain* called it an "obsolete pile." Replaced by the current 1888 structure, it brought $300 at auction, moved, became the Hopkins Hotel and was demolished in the 1970s. (Courtesy of Boyd Mattox, Johnson County Historical Society.)

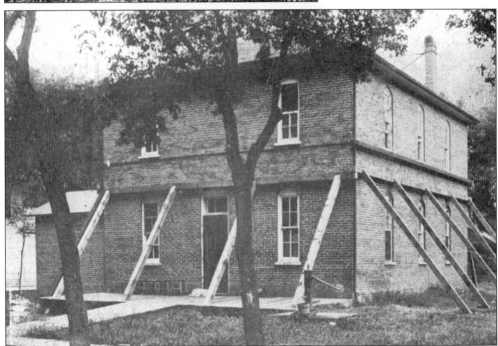

This is the first courthouse in Blair, Washington County. The county purchased this brick "commodious structure," built in 1869 as a school. To build a new courthouse the county commissioners declared the building unsafe, dramatized by placing heavy timbers outside to prop up the building. A similar story is related for the Scotts Bluff Courthouse in Gering. Farmers not wanting to approve floating the necessary bonds delayed new courthouse construction. It was sold in 1891 for $725.

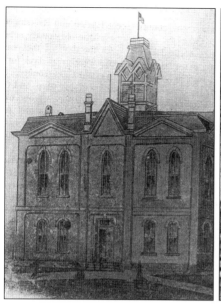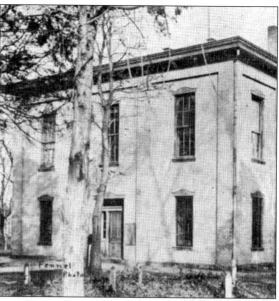

Top Left: Gage County was approved by a legislative act defining its boundaries in 1855. Whiteville, a paper town, was designated the first county seat. Beatrice won the county seat from Blue Spring in an 1859 election. This is the first courthouse. Building started in 1870, it cost $13,914, including the county treasurer's vault, and the county took occupancy in April 1871. It witnessed at least five murder trials. It leaked because of inferior workmanship. A new courthouse replaced it in 1892.

Top Right: Platte County boundaries were defined in 1856 out of Monroe, Dodge, and Colfax counties, with Columbus as the county seat. Columbus harbored aspirations to be the state capital. The Town House accommodated court in 1859. This 43 x 52 ft. courthouse, funded by $16,000 in bonds and designed for $50 by C.A. Speice, opened in 1867. "The workmanship throughout" was reported "as first class and pronounced by all that have examined it the most substantial and complete in its appointments of any courthouse in the state." It served until 1922.

Below: Acting Territorial Governor Thomas Cuming's 1854 proclamation created Pierce County, one of the original eight counties. Pierce became the county seat in an 1870 election. This is the first courthouse built in 1871 for $4,000. The elementary and secondary schools were built in the same year. Replaced in 1889, the courthouse moved across the street, served as a hotel, a dwelling house, and during the 1930s, as the Pierce Co-operative Creamery.

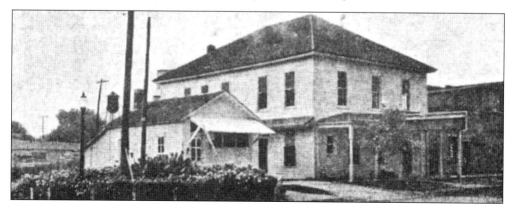

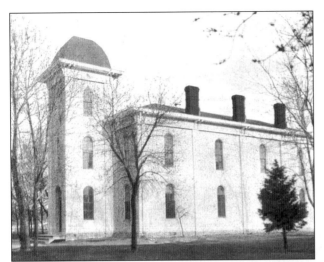

Colfax County, originally part of Platte County, was established in 1869. Schuyler replaced the first county seat of Buchanan. This brick building dating from 1871 had a tin roof, 40-foot ornamental tower, and a "beautiful wide stairway" leading to the courtroom. The jail is to the right. *Nebraska, Our Towns*, comments, "more than one horse thief was hanged from a branch of the big trees in the front yard." This courthouse, similar in style to Cuming County's structure, served until 1922.

Harlan County was separated from Lincoln County by the Legislature in 1871. Within a month, the county seat moved from Melrose to Alma. This building dates from the early 1870s. The largest building in town, the courthouse served as a landmark—a gathering place for social, professional and ethnic groups, and veteran reunions.

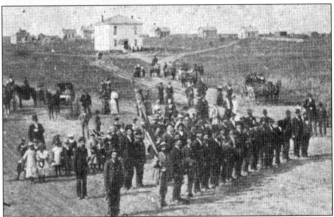

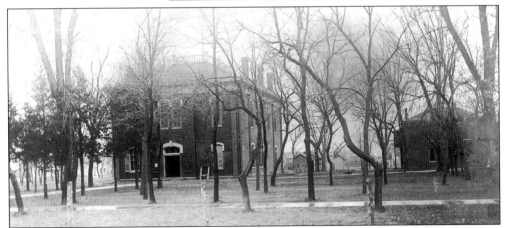

Merrick County was established in 1858. Central City soon replaced the original county seat, Elvira. Central City and Lone Tree feature prominently in the writings of Central City—born Wright Morris (1910–98). County offices were in the residences of various county officials until the erection of this two-story brick building in 1871. The current courthouse, built in 1915, replaced this structure.

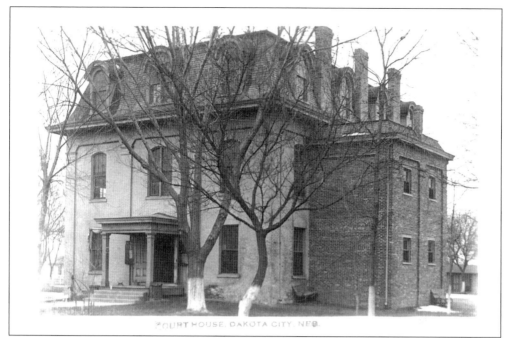

Dakota County, established in 1855, had Dakota City as county seat. For several years, court records were kept in a log courthouse, where fire and rodents took their toll. This 1871 courthouse contains yellow clay bricks made in Dakota City. Dakota City defeated the challenge of Saint Johns. A New Deal structure replaced this courthouse in 1940. Alvin Johnson, born near Homer, and president of New York's New School for Social Research, mentions the courthouse in his autobiography, *Pioneer's Progress* and novel, *Spring Storm*.

Polk County emerged from Butler County in 1870. The county seat is Osceola, though Stromsburg unsuccessfully contested it in a 1916 election. The first courthouse, started in late 1871 and completed in March 1872, burned down between 2 and 3 a.m. on January 1, 1881. Many of the county records, including the indexes to deeds and mortgages, were destroyed. This postcard, postmarked October 1912, celebrates the first courthouse and the jail on the right. (Courtesy Nebraska State Historical Society.)

Seward County, established in 1856, was called Greene County until January 1862, when General Greene joined the Confederacy. Milford defeated Seward and Camden in 1867. Seward replaced Milford as the county seat in an 1871 election. This original frame courthouse built in 1871-72, called a "beautiful structure" by the pioneers, cost $1,400. The railroad arrived in 1873. When it was sold in the 1880s for $50, it was moved half a block and became a blacksmith shop. The second courthouse was leased space on the second floor of a brick building housing the Bank of Seward County. Seward is noted for its Fourth of July festivities. (Courtesy Nebraska State Historical Society.)

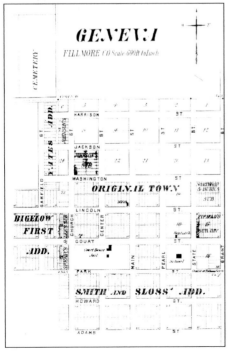

Fillmore County, established in 1856, and organized in 1871, had its county seat in Geneva. A "temporary" frame structure, often referred to as a "rickety old rat trap," costing $3,075, erected in 1872, served as courthouse for 20 years. Sold at auction in 1894 for $261, it became a dairy barn. The commissioners rented courtroom space above the Citizens Bank. This 1885 map of Geneva indicates the location of the courthouse, school and a church. According to Ward, A.J. Manley built a 20 x 60 ft. courthouse, in an unsuccessful bid to attract the county seat to Manleyville.

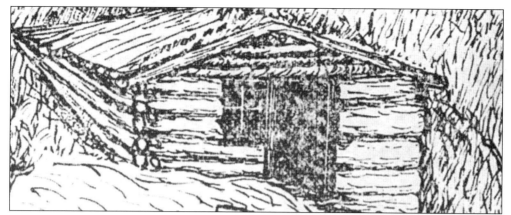

Above: Valley County, defined in 1871 and established in 1873, had its county seat in Ord. The Peter Mortensen dugout served as the venue for the first lawsuit in 1873, a case involving assault and battery with intent to kill.

Right: This log building is the first built specifically to be the Valley County Courthouse. For other log structures see Paddock, Brownville, and Callaway serving Holt, Nemaha, and Custer counties respectively.

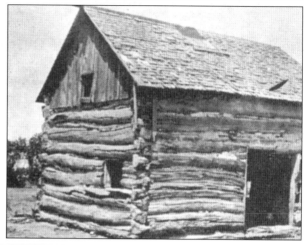

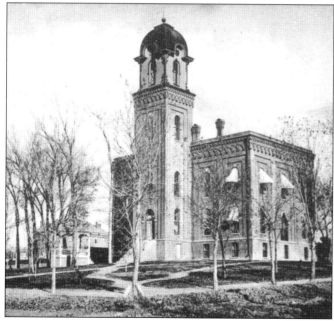

Cuming County, named after the acting governor of Nebraska Territory, was established in 1855. The claims of Catherine (a paper town), Dewitt, and Manhattan to be the county seat were eclipsed by West Point in October 1855. This 50 x 80 ft. brick courthouse, built in 1872 for about $40,000 and financed by bonds, was called a "magnificent structure" in 1892. It has been said, "The size of the original building showed the confidence early settlers had in the future of the county."

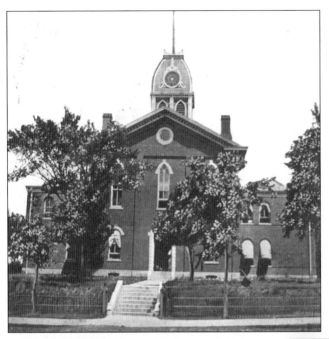

Richardson County dates from 1854. The first county seat, Archer, lost an 1857 election to Salem, which in turn lost an 1860 election to Falls City. Hard feelings resulted in violence. This brick courthouse, built in 1872, replaced a frame structure built in 1863 for $3,000. Heated by stoves and then a furnace, it burned down on May 7, 1919. A new building rose in 1925. The March 1908 postcard message reads, "Awfully windy. Looks like rain. Potatoes sprouting. Will sell some."

Below: Hall County, approved by the legislature in 1858, had Grand Island as its county seat. French trappers provided the initial name, *La Grande Ile.* Jules Verne's *Around the World in Eighty Days* set in 1872, was published in French in 1873. One English translation calls Grand Island, "Great Island." Bonds paying 10 percent financed the courthouse built in 1872 by Christian Anderson, for $16,500.

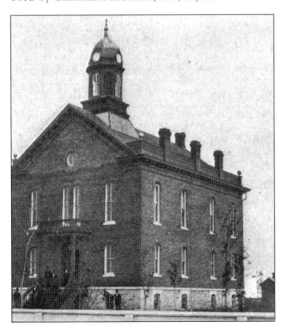

Above: Jefferson County, organized in 1864, was linked to Jones County on the west. It dissolved into two counties. The eastern part, Jefferson, clung to Gage County for judicial purposes from 1857 to 1864. Meridian, the initial county seat, lost that position to Fairbury in an 1871 election. This first brick building, with fire proof construction leased from a Lincoln firm, served as the courthouse in Fairbury from 1873 to 1892, and today still houses a business. (Photo courtesy of Sandra Stelling, Jefferson County Clerk.)

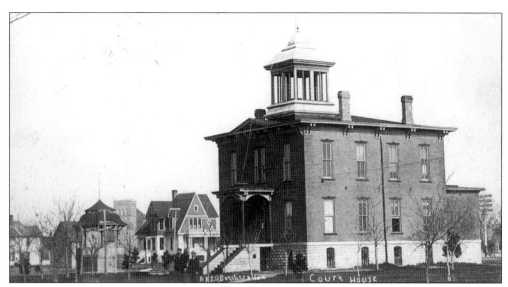

Dawson County, founded in 1871, had Lexington as its county seat. The "Immigration Reception House," built in 1872, served as the initial courthouse. Otto Hansen had learned brick making in Denmark, and built this "Grand Temple of Justice" in 1873-74 for $30,000. Poplars, catalpas, mulberries, and willows surrounded the building. The photo is attributed to Solomon D. Butcher. The grand jury condemned the building in 1912 and sold it for $448.

Wahoo replaced Ashland as the Saunders County seat in 1874. In an act some considered illegal, "they stole the county seat." The "conspirators" donated $5,000 for a county office building. This first courthouse in Wahoo, built by I.E. Phelps in 1874, cost $4,635. It was described in 1882 as "a neat appearing frame structure of modern architectural design, the foundation of which partakes of the form of a Greek cross, and crowning one of the highest elevations of the city." It was replaced in 1904. (Courtesy of Barbara Lewis Ziegenbein, Ashland, and Saunders County Historical Society.)

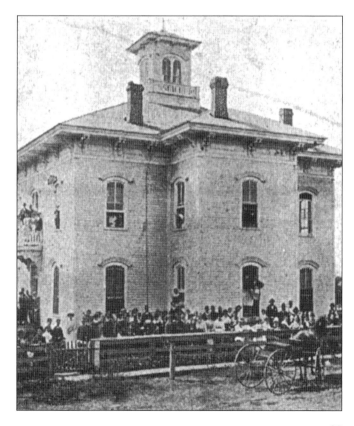

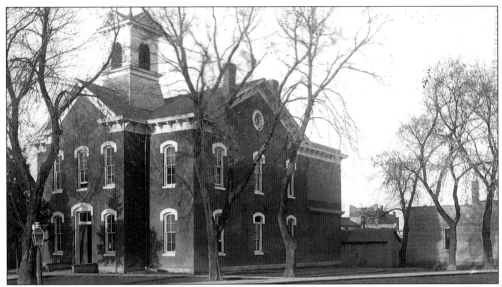

Papillion became the Sarpy County seat in 1875, defeating Bellevue and Sarpy Center. Ten thousand dollars was raised to build this brick courthouse. The festivities of setting the cornerstone on Saturday, July 3, 1875, (not on Independence Day, as it was a Sunday) were accompanied by a barbeque. The large hall hosted concerts. When replaced in 1923, the bricks were recycled into other structures.

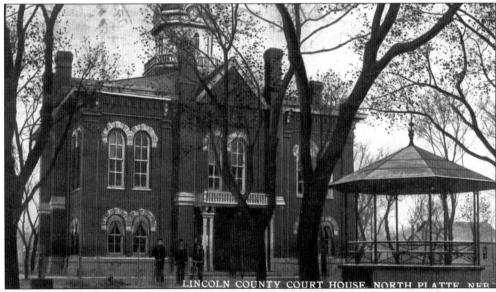

Lincoln County, originally called Shorter County, contained portions of Colorado and Wyoming, and was renamed in 1866. Cottonwood Springs served as county seat until 1867. The Union Pacific arrived in North Platte in 1866 and enhanced the town's position. Although funded in 1872, disagreements over siting the brick courthouse delayed construction until 1876. A new courthouse was authorized in 1921. The Taxpayers League invited auditors from Minnesota and the courthouse burned down on April 30, 1923. There were several indictments and convictions for embezzlement, forgery, and arson. (Courtesy of Anita R. Childerston, Clerk of Lincoln County District Court.)

York County, created in 1870, had York as its county seat. County affairs were initially held in the old pre-emption house. This first courthouse, built in 1876, was a plain two-story structure with an outside stairway. Town lots were sold to raise the $1,500 building cost. The school is on the upper right side. A new courthouse was built in 1888. (Courtesy of York County Historical Society.)

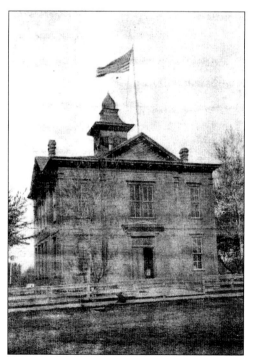

Above: This 16 x 24 ft. $800 frame storefront-type Valley County Courthouse in Ord replaced the log building. Financed by a November 1875 bond, it was completed in February 1876. The 200-pound safe from Cincinnati cost $1,000.

Left: Thayer County, originally called Jefferson County when organized in 1867, dates from legislative enactment in 1871. The county seat is Hebron. The first courthouse, a two-story wood structure completed in 1877, cost $5,375. The basement jail contained two small portholes. A better jail was built in 1888. Discussion regarding a new courthouse commenced in January 1900 and this courthouse burned down in July 1900.

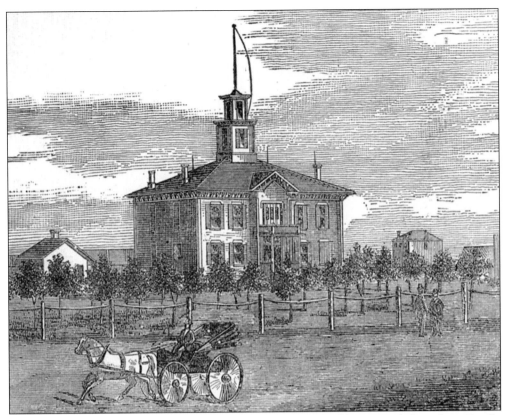

This Hamilton County Courthouse, in Aurora, replaced the building moved there from Orville City. Built in 1877, additions were constructed in 1886 and 1892. Like other courthouses, it served several functions being "used for church, Sunday School, social and political gatherings" and many pleasures were "enjoyed within its walls." This engraving of the Hamilton County Courthouse from *History of the State of Nebraska* by Alfred T. Andreas, appearing in 1882 is typical of the engravings used in published books, prior to the widespread use of photographs.

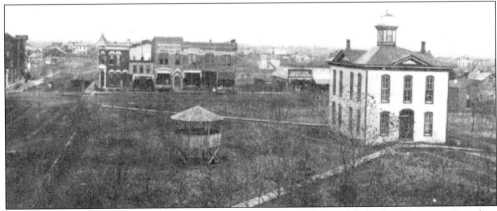

Kearney County was organized in 1860. The first courthouse, established in Kearney City, lost the seat to Lowell in 1872, which in turn lost it in an 1876 election to Minden. The Lowell courthouse cost $22,000. An 1878 modest-frame courthouse in Minden was replaced in 1879 by this more substantial 36 x 46 ft. building costing around $4,000.

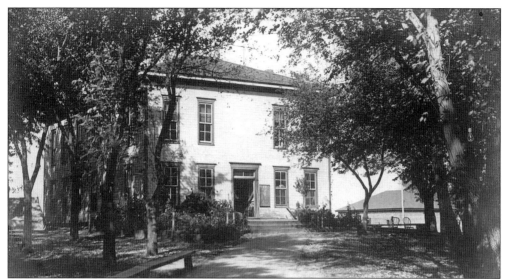

Howard County was organized in 1871. The new St. Paul schoolhouse housed the first term of District Court in 1874. This is the initial courthouse in the county seat of St. Paul, which was built in 1877. Described in 1882 as "a large and substantial frame building," it cost about $4,000. An attempt to relocate the county seat to Dannebrog failed. This building was replaced in 1913.

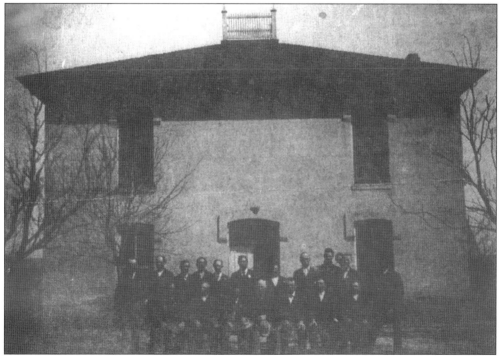

Sherman County, created in 1873, had Loup City as county seat. The first courthouse, built in 1874 and financed by $5,000 in bonds, burned down on its dedication day. The Burlington and Missouri Railroad gave the county $1,200 to rebuild the courthouse. This brick courthouse, built in 1878, retained some of the wall of the burned building. It was replaced in 1921

The first Saline County Courthouse in Wilber, the "Czech Capital of Nebraska," was built in 1878. Saline had defeated Crete and Pleasant Hill in 1877. Described in 1882 as "a very handsome two-story brick building" it cost about $16,000, derived from a $3,000 donation, $5,000 in bonds, and $8,000 from the county treasury. It was torn down to make way for a new courthouse. Crete was still unsuccessfully contesting county seat elections with Saline up to 1927.

Webster County boundaries were defined by the legislature in 1867, with Red Cloud as county seat. A dugout residence accommodated the first court, followed by a small log building. The Burlington and Missouri River Railroad built this courthouse in 1878, in return for the cancellation of some taxes. It was replaced in 1914. The cement vaults on each side of the building made dismantling difficult. The Red Cloud school district purchased the courthouse for the lumber—Michigan white pine. (Courtesy of Donna Lammers, Auld Public Library, Red Cloud, Nebraska.)

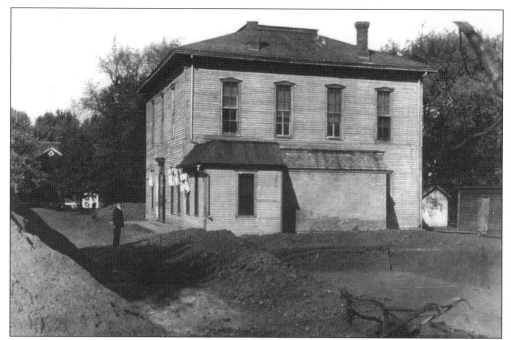

Burt County, named for the first governor of Nebraska Territory, was established in 1854. This structure, built about 1878, replaced the initial courthouse in Tekamah, a two-story log blockhouse, built by the War Department in 1855. This picture, taken in 1915-16, shows the excavation for the new courthouse in the foreground. (Courtesy of Bonnie Newall, Burt County Museum.)

Omaha expanded rapidly. This Douglas County Courthouse, built in 1882, stood on a lot bounded by Farnam, Seventeenth, and Harney Streets. Over 3,000 people, including more than a dozen civic and ethnic clubs, attended the cornerstone ceremony. Projected to serve 100,000 people this 115 x 123 ft. two-story building, with a basement, employed cut stone rather than brick. Built by a Detroit firm for $198,000, and described as a "handsome and abiding monument to the city," it was razed in 1913. See the cover of this book for the deceptiveness of single images and the illusion of permanence.

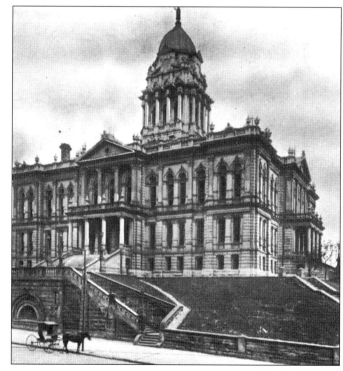

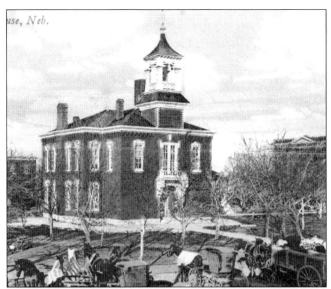

This $8,000 brick building, built in 1882, replaced the burned Polk County Courthouse in Osceola. T.D. Allen of Kearney designed it. Three vault doors from Diebold Safe and Lock Co. in Chicago cost $300. Trees were planted in 1886. Notice the absence of front windows on the main floor. The building was torn down in mid-1921 and replaced by the current building. (Courtesy Nebraska State Historical Society.)

Auburn, emerging from the union of adjacent settlements Sheridan and Calvert, received the Nemaha County seat in 1883. This modest wood-frame rental housed the first Courthouse. Built for $2,500 it brought $455 at an auction when the stone courthouse opened in 1900. (Courtesy Nebraska State Historical Society.)

Gosper County was organized in 1873. Daviesville, the original county seat, never built the proposed sod courthouse. Homerville won an 1882 election and built a courthouse in 1883. It had an unusual pagoda tower, but Nebraska winds prompted its removal. Elwood, served by the Burlington Railroad, became the county seat in 1888. They cut the frame courthouse into sections, loaded it on wagons and rebuilt it in Elwood, eight miles away. Fire destroyed it in 1895. (Courtesy Website, Western Cartographers.)

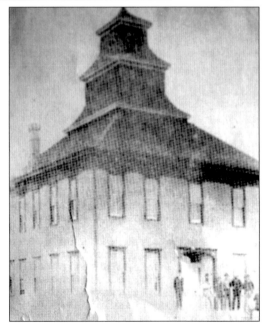

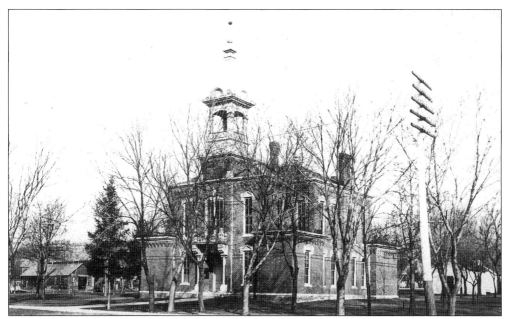

Stanton County, originally called Izard County, was created by the Legislature in 1862 and organized three years later, with Stanton as its county seat. In 1871, a 16 x 22 ft. frame building, built for $475, served as the courthouse. This courthouse, dating from 1883, cost $10,624. T. Dudley Allen of Cleveland and Minneapolis designed it for $200. Described in 1892 as a "massive brick courthouse," the tower was later removed. Pare criticized it as "Richardsonian, but in a crass and vulgar version." A postcard message commented "This is the court house. They have an old wooden jail in the rear." It was replaced in 1976.

Dixon County, initially part of Dakota County, was established in 1858. Ponca emerged as the county seat in an 1856 election that included Ionia, Concord, North Bend, and Ponca. Rivalry delayed building a courthouse. The 1883-84 courthouse is on the left. A 1908 postcard reports, "Came down here this morning to file cases." The 1940 addition is on the right. Dutch Elm Disease destroyed trees, but a Champion Blue Spruce thrives. Like the sturdy Burt County Courthouse, Dixon County's courthouse claims to be virtually tornado proof. The 55-year gap between original construction and the addition reveals changing architectural styles. See also additions in Otoe, Douglas, and Lincoln Counties. (Photo courtesy of Oliver B. Pollak.)

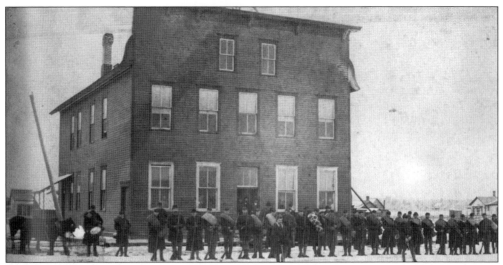

The boundaries of Cherry County, the largest county in Nebraska, were established in 1883. Rented space in Valentine accommodated early county business. In 1884, Hiram Cornell purchased the first courthouse from Fort Madison, an abandoned military post. It later served as Cornell Hall and Opera House and as an annex to the Donoher Hotel. (Courtesy Jane Graff and *Nebraska, Our Towns*.)

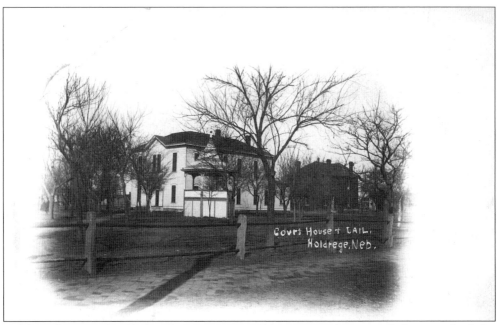

Holdrege became the Phelps County seat in 1884, in part because of the arrival of the Burlington Railroad. One source states the records were removed from Phelps Center to Holdrege by gunpoint. Local businessmen—at no expense to the county—built this "commodious" two-story brick building in 1884, *before* Holdrege won the county election. It was replaced in 1910.

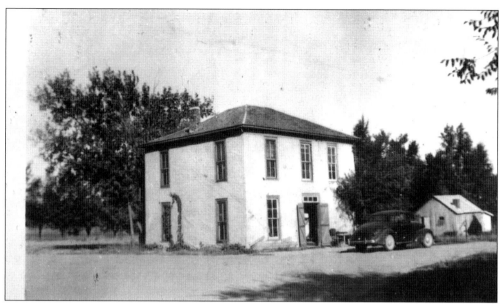

Loup County, originally called Taylor County, was created by the legislature in 1855 and renamed in 1883. Almeria replaced the first county seat, Kent. Taylor defeated Almeria in an 1883 election. A rancher who wanted the county seat in Taylor, built this two-story, four-room building, called the "winter icebox," in 1884—at no cost to the county. "Dilapidated and unsanitary" with inadequate plumbing and heating, it brought $238.36 at a June 1958 auction.

Deuel County was formed in 1888, formerly being part of Cheyenne County. Froid, Big Springs, and Chappell vied for the county seat. In addition to stormy elections, the siting of the county seat in Chappell had to be settled by the Nebraska Supreme Court. This first courthouse, originally an 1885 schoolhouse, was moved to make way for the current courthouse, completed in 1915. It is now part of a farmhouse. (Courtesy Lester L. Becker, Chappell, Nebraska.)

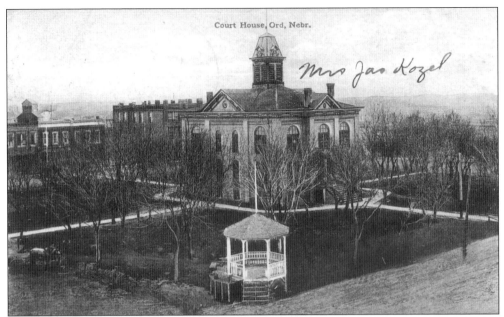

Court House, Ord, Nebr.

Mrs Jas Kozel

This Valley County Courthouse in Ord, designed by Duferene and Louis Mendelssohn of Omaha (German-born Mendelssohn later played a prominent part in the Body by Fisher Corporation) took over 20 months to complete, partly due to a destructive storm on September 11, 1885. Made of poor quality brick, the contractor probably lost money on this commission, not unusual in courthouse contracts. Torn down in 1921, the bricks went into a sewer. Bandstands were typically found in courthouse squares.

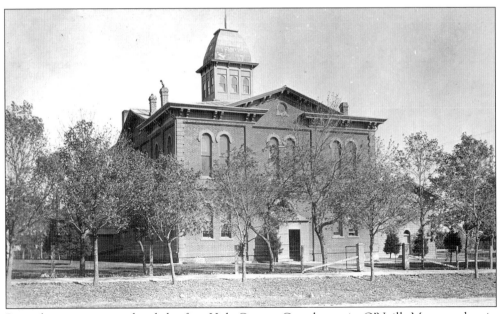

Rented space accommodated the first Holt County Courthouse in O'Neill. Many settlers in O'Neill had Irish roots. This courthouse, dating from 1885, cost $18,000. From 1885 to 1904, there were at least five attempts to change the county seat. The current New Deal-era courthouse, built in 1936, replaced this building.

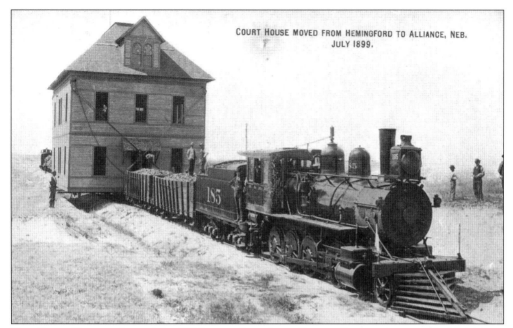

COURT HOUSE MOVED FROM HEMINGFORD TO ALLIANCE, NEB.
JULY 1899.

Box Butte County, formed in 1886 out of southern Dawes County, has a colorful history. Nonpareil, the initial county seat, lost to Hemingford in 1890, which lost to Alliance, a division point of the Burlington Railroad, in 1898. They moved the building 20 miles to Alliance by train in early 1899. This courthouse is similar to Imperial's Chase County courthouse. Written on the back of the postcard is the statement: "This is our Court House. But we are going to have a new one $75,000 in the spring." It is now a private residence.

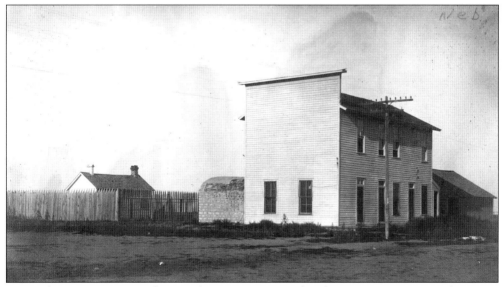

Keya Paha County, previously part of Brown County and Holt County, was organized in 1884. NACO states that 15 different settlements vied for the county seat. It came down to Springview defeating Burton. This is the courthouse and jail, completed in 1886 at a cost of $1,126. During an Indian scare, it served as a fort. At auction in February 1915, the courthouse brought $160, the jail $26, and the woodshed, $38.

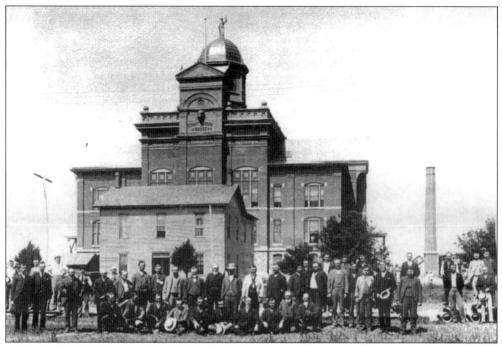

Buffalo County was created by legislative act in 1858, and organized in 1869. Gibbon became the county seat in an October 1871 election. This first Buffalo County Courthouse in Kearney, a frame building, was built in 1886 on land donated by the Union Pacific Railroad. It is dwarfed at the 1890 dedication by the grand brick courthouse. The frame building was moved and continued to serve as a WCTU hospital and subsequently as a home for Veterans of Foreign Wars. (Courtesy of Cindy Messenger, Kearney Public Library and Information Center.)

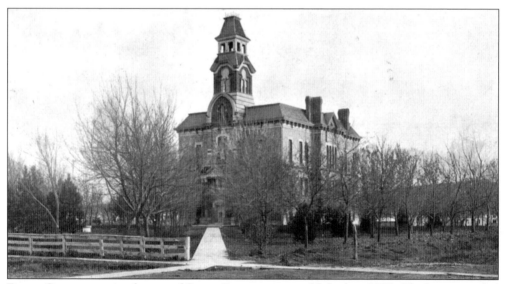

Dawes County, previously part of Sioux County, was established in 1885. Chadron prevailed over Dawes City as the county seat. This courthouse, built in 1887 at a cost $35,000, received some criticism for its "enormous outlay." The trees were planted and cared for by Mary Smith-Hayward, a local businesswoman. This courthouse was replaced in 1936.

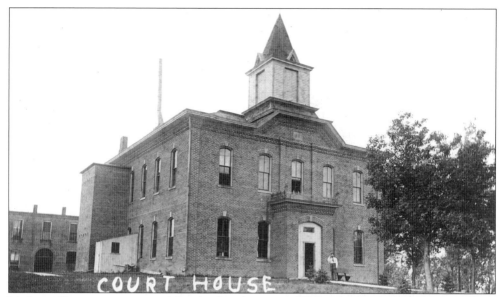

Madison County was approved by the Legislature in 1856 and organized in 1867. Madison defeated Battle Creek and Norfolk to become county seat in an 1875 election. An 1892 commentator described this building, designed by C.F. Kaul and completed in 1887, as a "commodious brick courthouse." The $7,000 courthouse had walls twelve inches thick, with locally produced bricks. The Civilian Conservation Corps removed the tower in the 1930s. Torn down in 1977, the site now serves as a parking lot for Madison High School. Keeping the county seat in Madison, rather than the more populous Norfolk, has been likened to a "civil war."

Nuckolls County was organized in 1871. Nelson prevailed over Elton and Vernon in 1872 as the county seat, and survived Superior's 1889 challenge. The arrival of the railroad in Nelson solidified its hold. County government moved from an inadequate $2,500, 1873 building into rented space in the Nelson Opera House, built in 1887. It housed the courtrooms as well as the Columbia Theatre, photo studio, library, and Scully land office. The citizenry soon voiced resentment about renting private buildings for official purposes. It was destroyed in 1935. (Postcard courtesy of Andrea Faling, Lincoln, Nebraska.)

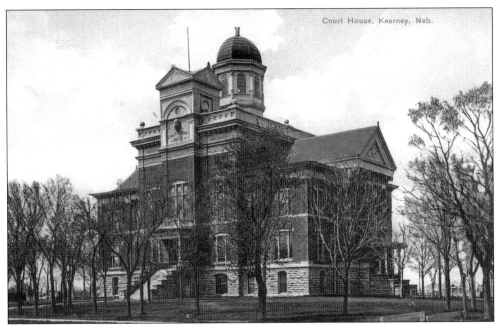

Kearney, county seat of Buffalo County, created monumental architecture in its courthouse, post office (now the Museum of Nebraska Artists), and the Great Platte River Road Archway Monument over Interstate 80. According to Goeldner, the Buffalo County Farmer's Alliance requested a grand jury investigation of the $100,000 price tag, and other shady practices regarding this building, designed by W.E. Wagner of Kearney, erected 1887–90. The head of a sharp-horned buffalo adorns the facade, adding to the building's "uniqueness" and "naivete." The courthouse was remodeled after a major fire in February 1935. It was torn down in the 1970s.

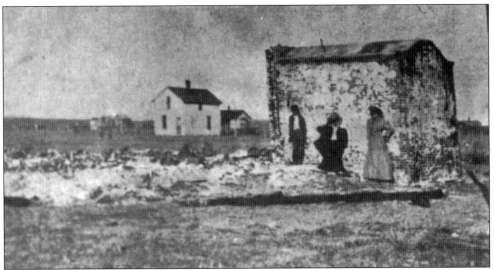

Blaine County was established in 1885. Brewster won the election in November 1887, and replaced Ladora, the initial county seat. According to Perkey, most of the buildings in Ladora were dismantled and moved to Brewster. This courthouse, built in 1888 for $2,185, included a vault. The fire that burned it to the ground on September 7, 1907, was characterized as "of a suspicious incendiary nature." Only the vault remained. (Courtesy Al Schipporeit, Brewster, Nebraska.)

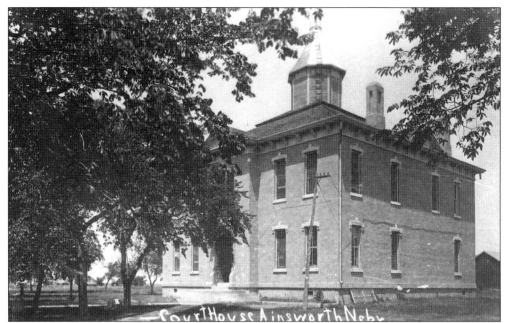

Brown County was established in 1883. The courthouse occupied several rented premises, including the Ainsworth Opera House and Osborne Hotel. This courthouse in Ainsworth was built in 1888, following a nullified and then a valid bond election, at a cost of $9,750 ($1,000 for furniture). Lightening caused some damage to the courthouse in July 1889. It burned down Easter morning, April 6, 1958, and the cold froze the fire siren.

Clay County was established by an act of the legislature in February 1867. Sutton defeated Harvard and then the county seat moved to Clay Center after an 1879 election. Ward calls this a compromise contrived by Harvard, Sutton, and Fairfield. The records were whisked out of Sutton in the dead of night into a one-story frame building in Clay Center. The resulting conflict reached the Nebraska Supreme Court. Built in 1888, the bricks were made about one mile west of Benkelman. It was replaced in 1921. (Courtesy Nebraska State Historical Society.)

Furnas County was created in 1873. Beaver City won the county seat from Arapahoe in October 1873, but legal challenges took the issue to the Nebraska Supreme Court. The courthouse shared space with a hotel and hardware store that were torn down in 1894. This courthouse, dedicated on May 17, 1888, cost $10,000. *Pioneer Stories of Furnas County, Compiled from the files of the Beaver City Times-Tribune* (1914) contains five photographs taken from the courthouse cupola. It was declared unsafe for occupancy in 1948 and dismantled in 1949.

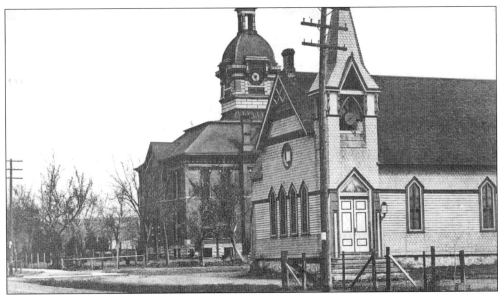

Keith County was organized in 1873. According to Olson and Naugle, citizens moved a frame house from Brule to the county seat in Ogallala to serve as the courthouse. This courthouse, built in 1888 with brick kilned in Ogallala, is seen juxtaposed with the Methodist Church. Citizens approved a $25,000 bond issue with C.C. Rittenhouse as the architect. The clock tower was removed in 1922 and the building replaced in 1963. (Details courtesy of Jack Pollock, *Keith County News.*)

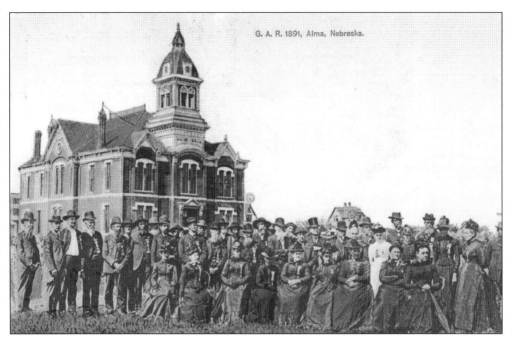

This brick Harlan County Courthouse in Alma was built in 1888. Standing in front of the building are members of the Grand Army of the Republic (Civil War Veterans), meeting in 1891. The appearance of this courthouse changed dramatically, as the next picture demonstrates. (Courtesy Nebraska State Historical Society.)

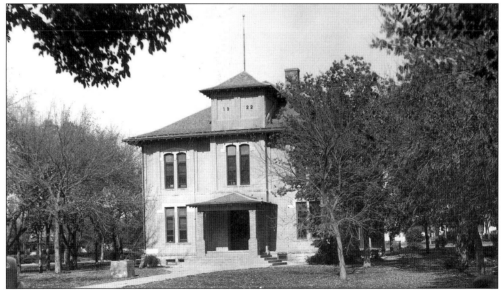

This is the same Harlan County Courthouse as above. It lost its tower in a 1911 windstorm, received a stucco exterior in 1922, and was torn down in 1964. In 1910, Edna reported: "The Southwest Nebraska Teachers Association was held at Alma. Alma teachers gave the visitors a reception in the Court House." As late as 1918 Nebraska had 7,655 schools, many of them one-room school houses. Teachers took short courses at teachers' institutes administered by superintendents of public instruction.

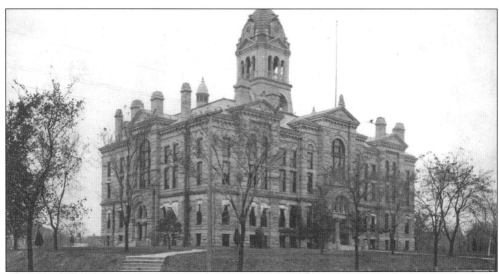

The legislature approved the boundaries of Lancaster County in 1855. Lincoln (formerly known as Lancaster), established as a compromise to remove the state capital from Omaha, expanded with the building of the state capital, State Penitentiary, State Insane Asylum, University and Historical Society, and was soon the second largest city in the state. According to Goeldner, the Lancaster County Commissioners allocated $200,000 for the building and rejected the first $320,000 design of E.E. Myers. This county courthouse, built in 1888 and designed by F.N. Ellis of Omaha, cost $164,976. Laura Ingalls Wilder in *On the Way Home* wrote of her 1894 journey, "The County Court House and the Capitol are grand buildings, and so is the penitentiary." The postcard noted, "This court house was just across the street from my last rooming place. Quite pretty in summer, the grass all green and the trees." This building was replaced in 1967.

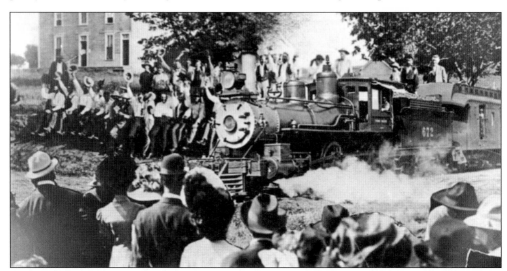

The boundaries of Wheeler County were established in 1877. The county seats have been Cedar City, Cumminsville, and since an 1885 election, Bartlett. Ericson unsuccessfully challenged Bartlett in 1909. John Nelson, a photographer, fabricated this postcard of the first courthouse, a two-story frame building built in 1888. There was no train near the courthouse. The courthouse was destroyed by fire in September 1917. Fortunately, courthouse officials had purchased a $500 fireproof safe in 1894. (Courtesy Nebraska State Historical Society.)

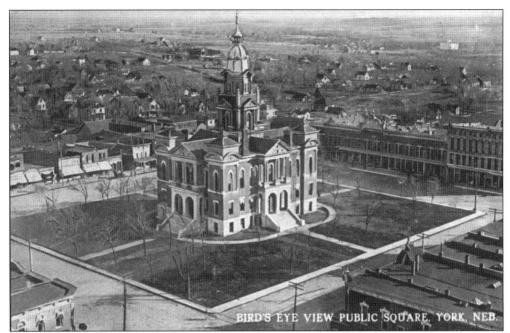

This York County Courthouse, started in 1885 and completed in 1888, was designed by O.H. Placey, who had offices in Chicago and Lincoln. The building cost between $48,901 and $60,000. Remodeled in 1953 for $45,000, portions were condemned during the 1970s because of deterioration. It was demolished in June 1978.

The second Custer County Courthouse, the first in Broken Bow, was built in 1884 and cost $1,432. This is the third Custer County Courthouse, built in 1888-89 on land donated by Jesse Gandy and with $15,000 donated by citizens. NACO describes it as a red brick, ornate structure with rounded towers on the corners. It burned down on January 15, 1910.

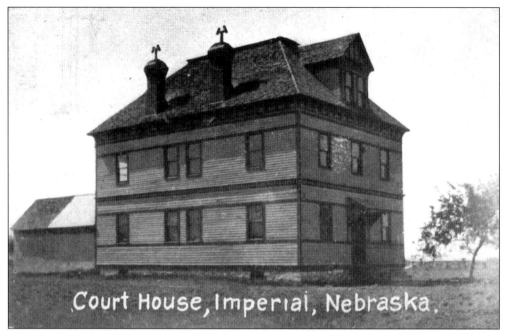

Court House, Imperial, Nebraska.

Chase County, established in 1886, was formerly part of Keith County. The first two-story wood frame courthouse in Imperial, built in 1889, occupied land donated by the Lincoln Land Company. The Burlington Railroad came to Imperial in 1892. The courthouse burned down in February 1910. Its design is very similar to that of Box Butte County. The current courthouse stands on the same location as this one.

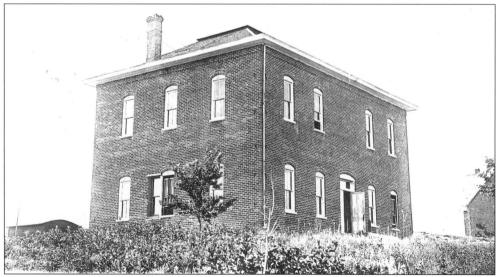

U.S. Judge Elmer S. Dundy provided the name for Dundy County, created in 1873. Allston vied unsuccessfully with Benkelman to be the county seat. This original courthouse in Benkelman, built of locally-made bricks around 1889, received support from the Lincoln Land Company, $1,800 from Benkelman, and $1,500 from the county. Auctioned for $470, it was torn down in 1922.

Frontier County, organized in 1872, had its county seat in Stockville. The first courthouse, a 16 x 16 ft. log structure built in 1872, burned down in 1883. This frame courthouse, in the square on the main street, was built in 1889. The cost was $3,400, funded by a tax on real and personal property. There were challenges in 1920, 1930, and 1950 to move the county seat to Curtis. This is the last courthouse in America to get indoor plumbing and to be served by a paved road. According to Pare, "Courthouses in the wooden vernacular of rural American building have rarely survived from the second half of the nineteenth century." (Photo courtesy Darla M. Walther, Frontier County Clerk.)

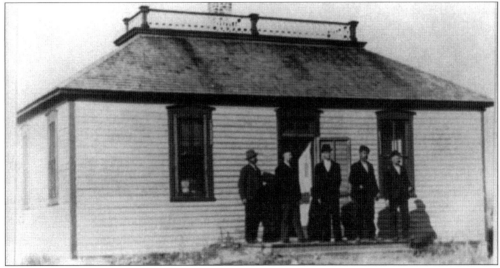

Hooker County, created by the Legislature in 1889, had its county seat in Mullen. The first courthouse, a frame one-story 26 x 24 ft. two-room building, built in 1889 at a cost of $1,500, included a jail. When the current courthouse opened in 1912, this building moved across the street to become the central part of the Hooker County Tribune Building. (Photo and information courtesy of Frank E. Harding, Mullen, Nebraska.)

51

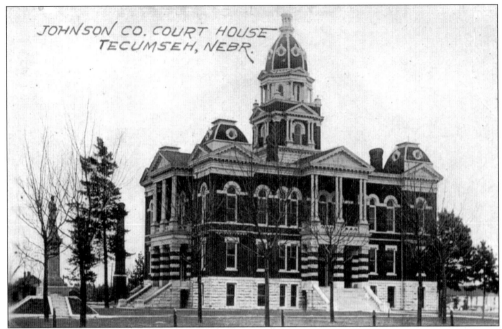

William Gray designed the Romanesque Revival-style Johnson County Courthouse in Tecumseh. Voters approved a bond issue in 1888 and completed this building in 1889 at a cost of $40,000. The eyelets in the cupola were later removed. Like many courthouses, Johnson County maintains an "avenue of flags" to honor veterans of all wars. Tecumseh was featured in the 1987 ABC television mini-series *Amerika*.

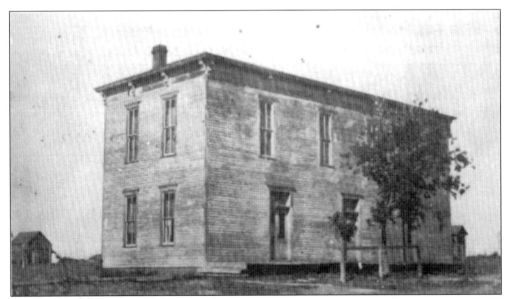

Perkins County was formed from Keith County in 1887. Grant won the distinction of county seat in an election defeating Lisbon and Madrid. They called this first courthouse, a two-story frame structure built in 1893, the "Old White Elephant." The court moved into a repossessed brick bank building in 1901. The A.O.U.W. purchased the 1893 building. It served as a community hall until razed in 1940. The Grant Masonic Temple built on this site in 1953.

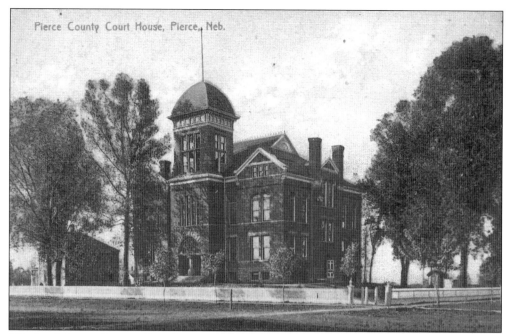

Pierce County Court House, Pierce, Neb.

This brick Pierce County Courthouse in Pierce, designed by Fisher and Russell of Omaha, built in 1889, cost $25,000. Electric lights replaced kerosene in 1908. The tower was removed in the early 1930s for safety. According to *Nebraska, Our Towns*, this "beautiful old courthouse fell to the wrecking ball in 1974, despite opponents' wishes."

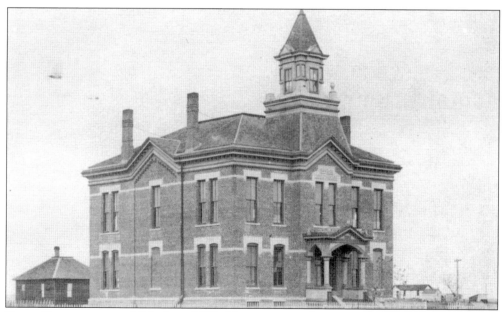

Sioux County was established in 1877. Harrison won the county seat in a January 1887 election, defeating Andrews, Bodarc, Montrose and the S.E. Smith Ranch. The county seat election and the election for the $10,000 bond issue may have had some irregularities. Architects Whitney and Murphy designed this courthouse, built out of locally-produced brick and dedicated in 1889. The building was replaced in 1931.

Thomas County, first homesteaded in 1880, was organized in 1887. Thedford is the county seat and survived a 1920 election challenge from Seneca. This second courthouse, built in 1889 of fired brick, replaced a temporary wood structure built in 1888. Destroyed by fire in October 1920, the *Thomas County Herald* reported that although the building was a total loss the contents of the big safe and two vaults were unharmed. A 12 x 24 ft. wood structure was used until 1923. (Courtesy of the Nebraska State Historical Society.)

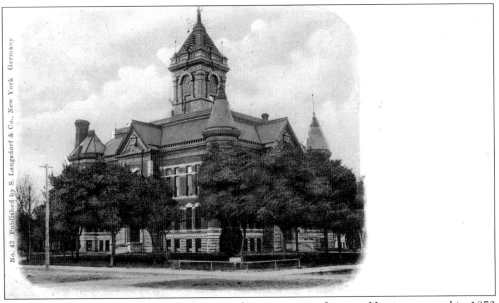

Adams County, created in 1867, had its initial county seat in Juniata. Hastings, served in 1872 by the railroad, displaced Juniata in a bitter 1878 election. This courthouse in Hastings, built in 1889-90 for $75,000, is depicted in over 14 postcards. A 1909 postcard message observed: "This is the place where Adams County Prisoners gets justice meted out to them. No Sunday Ball Games here." According to the 1939 *Hastings Daily Bee*, "people came from their sod houses to look upon" this "veritable castle" and its "marvels." A 1,000-pound, 10-foot tall statue of the Goddess of Justice, was removed in 1921. Renovation in 1941 removed the turrets and slate roof. Razed in 1965, today it is a city park.

Banner County, previously part of Cheyenne County, was created in 1888. Banner, Freeport, Ashford, and Harrisburg vied for the county seat. Ashford held this position from January 25, 1889, until Harrisburg won the election on May 22, 1889. This courthouse was built in Harrisburg in 1890. Harrisburg is one of two unincorporated Nebraska villages that serve as a county seat. The other is Tryon. The courthouse was replaced in 1958.

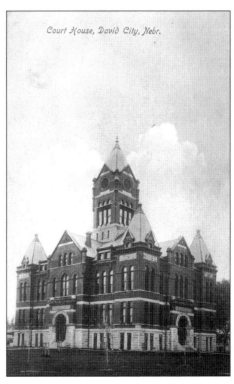

Butler County was established in 1856 and organized in 1868. Savannah replaced the paper town county seat of Mahala City. David City soon replaced Savannah. The 20 x 32 ft. courthouse in Savannah moved to David City, becoming the David City House hotel. Later, it was destroyed in an 1887 cyclone. The modest "neat and commodious" courthouse, built in 1873 for $1,470, soon proved inadequate and became a hotel, cold storage facility, and a wire factory. "An eyesore" to the David City citizens, the fire warden condemned it in 1912. The courthouse pictured here dates from 1890. On February 12, 1920, Hubby wrote to Wifey, "What do you think of the court house here? It stands in the center of the square about which are the several places of business." This "majestic three-story brick edifice" was replaced in 1964. (Courtesy of David City Library Foundation.)

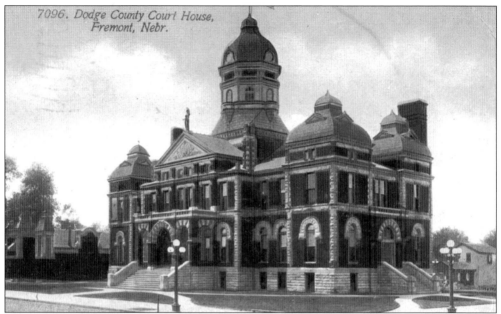

Dodge County voters approved a $50,000 bond issue and Fremont voted $10,000 in 1888 for a new courthouse to replace the 1867 structure that burned in 1887. Dedicated in 1890, this building contained "cheerful rooms for every county official." It burned in 1915. In 1909, Will wrote to Miss Frances in Putnam, Illinois, "Thanks for your postcard. This is a scene of Fremont where I attended college. Hoping to hear from you again soon. Tell me your age. Mine is 21 years."

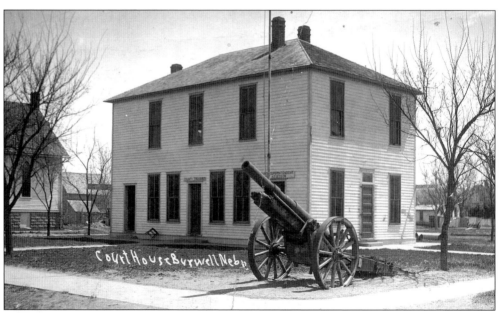

Garfield County was formed from the western part of Wheeler County in a November 1881 election. The Burlington and Missouri River Railroad was built to Burwell in 1887, causing Willow Springs to lose the county seat. The county safe moved to Burwell in April 1890. The signs above the doors of this wood building included "County Treasurer" and "County Superintendent Assessor." The courthouse, built in 1890, served until 1963.

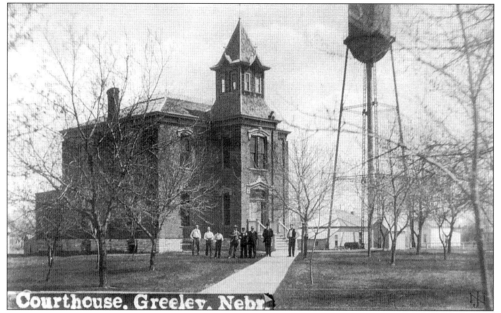

Greeley (formerly known as Spading and Greeley Center), served by the Burlington and Missouri Railroad, had better transportation than Scotia, thus becoming the Greeley County seat in 1890, after defeating Scotia and O'Connor. Greeley citizens celebrated with a barbeque. The Lincoln Land Company donations and a popular subscription financed this first Greeley courthouse, built in 1890. The two-story structure cost $5,000. Greeley boosterism resulted in the completion of the courthouse before Scotia lost its position. It was replaced in 1914.

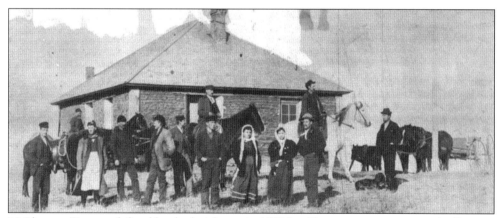

McPherson County, defined by the legislature in 1887 has Tryon, an unincorporated village, as county seat. This 1890 sod courthouse had a hip roof with rafters and sheeting covered with tarpaper and more sod. The courthouse, enclosed by a barbed wire fence, deterred roving livestock from rubbing against the sod walls. The building was later enclosed by a frame, the sod walls removed, and the roof shingled. When deteriorating it was said, "the roof was held up by the wallpaper." It was replaced in 1926.

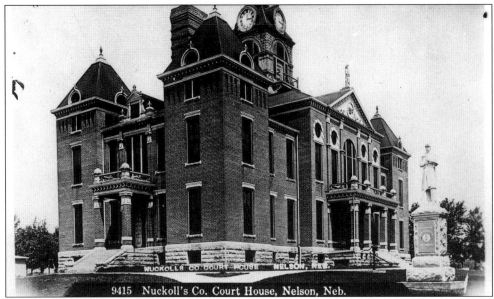

9415 Nuckoll's Co. Court House, Nelson, Neb.

This Nuckolls County Courthouse in Nelson, designed by George F. McDonald, cost $32,010, and was financed by an 1889 bond issue. The Opera House Band, Nelson's Company of the National Guard, Knights of Columbus, Nelson and Superior town bands, as well as 40 barrels of lemonade, 15 barrels of water, 5 barrels of coffee, "plus tons of other delicacies" accompanied the June 1890 cornerstone ceremony.

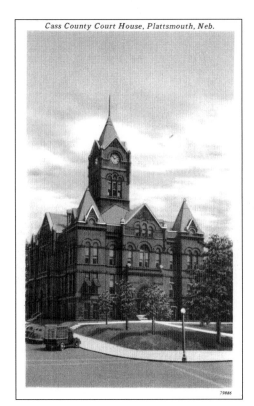

Cass County Court House, Plattsmouth, Neb.

Plattsmouth maintained its position as Cass County seat, in the face of a challenge from Weeping Water, by securing a bond issue for a new courthouse. This courthouse, designed by Lincoln architect, William Gray, who also designed the Hamilton and Johnson County Courthouses, was built in 1891. Still in use, it is a fine example of Romanesque Revival. The 80 1/2 x 102 ft. building cost $70,000 to $80,000. The brownstone came from Bayfield, Wisconsin and the pressed bricks from Kansas City. A message on the back of the postcard notes, "This is the County Court House where we all get married by the Police Judge. Don't forget." According to Goeldner, four telephones were installed in 1892 for $3.20 per month each. By 1900 in Iowa, the cost had dropped to $1.25 per phone.

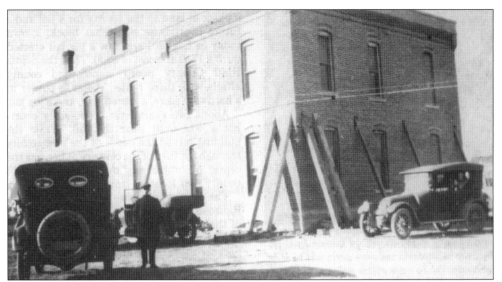

Scotts Bluff County was formed out of Cheyenne County in 1888. Court met in Gering at Sayre's Hall. Gering Joint Stock Company donated Legion Park for the courthouse site. This two-story courthouse, completed around 1891, joined a log jail built in 1889. By 1917, it was "getting rickety" as evidenced by the dramatically heavy timbers allegedly supporting the walls, perhaps a ruse to promote a bond issue. (Courtesy Jamilee Clark and Carol Klingman Bangerter, Gering, Nebraska.)

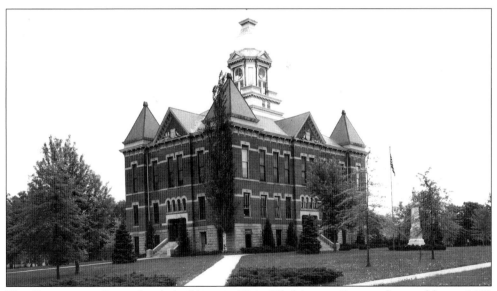

This Romanesque Revival-style building, in Blair, Washington County, financed by an 1889 $35,000 bond issue and a $5,000 contribution by Blair, was completed in 1891. According to Goeldner, the architect O.H. Placey became so disgruntled that he told the County Supervisors that "he positively refuses to have anything to do in and about the further work and completion of the New Court House and bid the Board good bye and took his hat and passed out." Washington County claimed to have "one of the most elegant county buildings in Nebraska." Remodeled in 1936 with a WPA grant, changes made after 1967 included lowered ceilings and wall paneling. It was re-roofed for the first time in 1980.

CEDAR COUNTY COURT HOUSE, HARTINGTON, NEB.

Cedar County was established in 1857. The county seat moved from St. James to St. Helena and in 1885 to Hartington, which was served by a railroad. Voters passed a bond issue in 1891 to build this Romanesque Revival courthouse in Hartington, completed in 1892. This modest and economical structure, designed by J.C. Stitt of Norfolk, cost $19,999. The Hartington City Auditorium, like the Prairie style Sioux City Courthouse, was designed by a Sioux City architect who had worked with Louis H. Sullivan. The 1909 message to Newport, Rhode Island notes, "Very glad to exchange cards with you." County officials expanded the vault in 1941, and built a new jail for $310,698 in 1973.

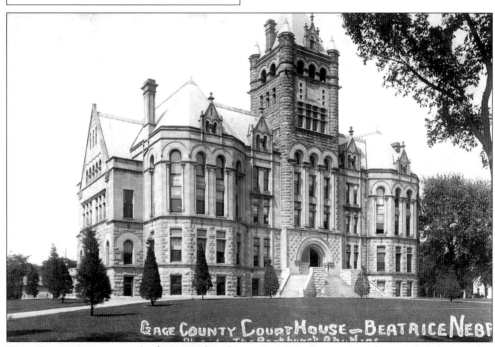

Gage County voters passed a $100,000 bond issue in 1889. Contentious financing issues went to the Nebraska Supreme Court. Gunn and Curtis of Kansas City, Missouri, designed the building. Construction of this Richardsonian Romanesque building in Beatrice started in 1890. It opened in 1892 on the same site as the original courthouse. Laura Ingalls Wilder in *On the Way Home* wrote, "We saw the courthouse, it is handsome." In 1954, the tower windows were bricked in and the flat roofs sloped. A fire on January 7, 1960, almost finished this building. The dormers were removed and the clock from the 1890s post office was added in the 1960s. According to Goeldner this is "one of the finest Romanesque courthouses." Courthouse rededication occurred in 1991.

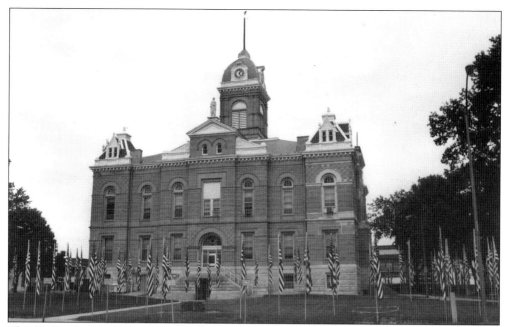

This Richardsonian Romanesque Jefferson County Courthouse in Fairbury has a central clock tower. The courthouse, designed by architect J.G. Holland (of Topeka, Kansas and Lincoln), and completed in 1892, cost $56,943. Stonecutters were brought from England. A message on a postcard observed, "the town is built all around the Courthouse, nice place." Goeldner described the structure as a "reluctant adherent of the Romanesque style." Dressing the lawn with flags on Independence, Memorial, and Veterans Day is common. (Photo courtesy of Harold Stelling and Sandra Stelling, Jefferson County Clerk, Fairbury.)

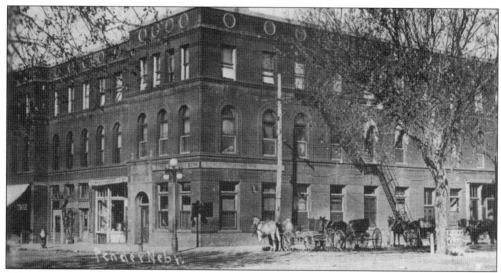

Thurston County, established in 1889, previously known as Blackbird County, had its county seat in Pender. The courthouse started in a small frame building and then leased the second floor in the adjoining Palace Hotel, which had been built in 1892. The lack of a separate county facility prompted Walthill to contemplate challenging Pender for the county seat. In 1927, Pender converted an 1895 schoolhouse into a courthouse.

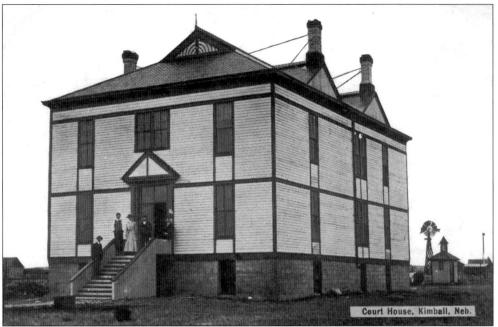

Court House, Kimball, Neb.

Kimball County separated from Cheyenne County in 1888. Kimball defeated Dix for the county seat in an 1889 election. This frame courthouse, built in 1893, was funded by a $5,000 bond issue, similar to that in Alliance and Imperial. George E. McDonald received $50 for the plans. It had a stone basement for a jail. The windmill cost $122.20 and digging the well, $106.70. Each room had a stove and a coal bucket. The current granite structure replaced this courthouse in 1928.

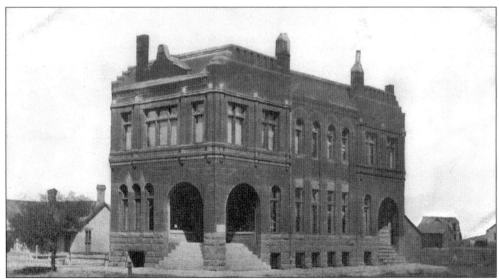

This stone, two-story Perkins Courthouse in Grant, formerly was known as the First National Bank Building (built in 1899), which claimed to be the largest building between Holdrege and Sterling. It failed in 1895. The county government had $8,000 in deposits. The building became the courthouse in 1901. Replaced in 1927 by the current courthouse, it now stands vacant.

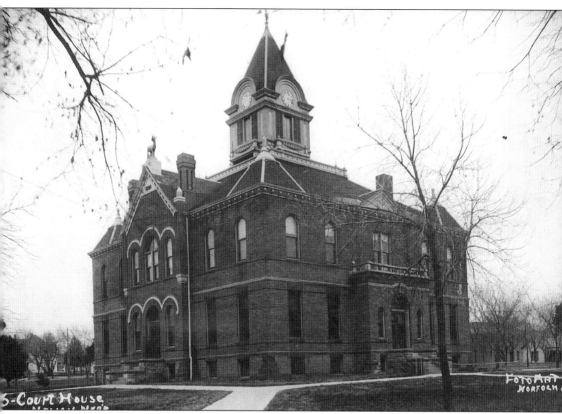

5-Court House

Antelope County was created in 1871. After several elections, Neligh replaced Oakdale as county seat in 1883. The 1873 Oakdale one-story frame courthouse, costing about $700, burned down in October 1875. The courthouse in Neligh, designed by George E. McDonald (costing about $15,000), opened in 1894. The clock was removed in the 1960s. The Neligh Ladies Auxiliary of the Grand Army of the Republic (Civil War Union Army veterans) raised the money for the antelope statue above the entrance. The antelope glows when the sun shines. The National Register for Nebraska defines Romanesque Revival, which flourished from 1880 to 1920 as follows: "These buildings are of masonry construction and usually show some rough-faced stonework. The Roman or round-topped arch is a key feature. Facades are asymmetrical and most examples have towers, brick corbelling (overlapping arrangement of bricks producing a series of projections from the wall) and horizontal stone banding."

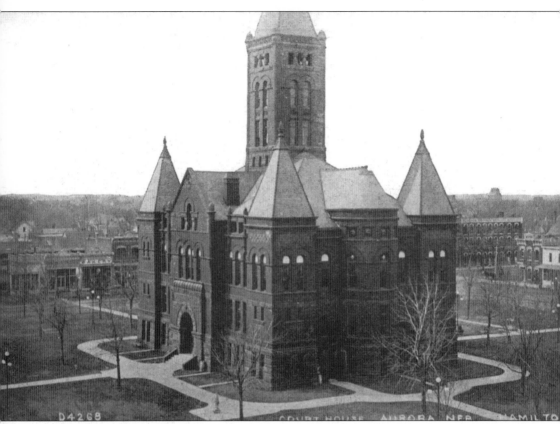

Hamilton County's Richardsonian Romanesque-style courthouse in Aurora, designed by William Gray in the County Capitol form, and dedicated in 1895, replaced the burned down structure. Built for $55,395 it utilized red and white limestone. The National Register for Nebraska defines County Capitol, a style flourishing from 1880 to 1900 thus: "This was a popular form for courthouses in the state and was inspired by the U.S. Capitol in Washington D.C. Usually situated on a courthouse square, these square-shaped monumental buildings exhibit corner pavilions (tower-like projections), a prominent central domed tower, and Neo-Classical or Romanesque styling." Goeldner wrote, "Few nineteenth century courthouses have been so immaculately maintained ...uncluttered corridors exhibit patterned tile floors and oak woodwork in pristine condition." In the 1970s, it received suspended ceilings; in the 1980s, $220,000 for new heating and air conditioning; and in the 1990s, $135,000 to make the building compliant with the Americans with Disabilities Act, including an elevator. The next task is to remove the suspended ceilings.

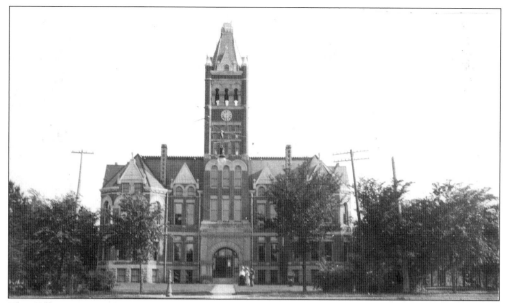

The Fillmore County Courthouse in Geneva, designed by George E. McDonald, featured a three-story clock tower, and was dedicated in 1894, at a cost of $46,176. According to Goeldner, it lacks "the subtleties" of the Gage Courthouse of which it "is an obvious imitation." The "plagiarism of George E. McDonald seems not to have offended the public conscience." The National Register for Nebraska defines Richardsonian Romanesque (flourishing between 1880 and 1920), as follows: "Richardsonian Romanesque also displays round-arched styling, but buildings contain more rock-faced masonry than Romanesque Revival structures. Large arched entries and transomed windows set deeply into the walls are evident." The 2001 rededication included the Grand Lodge of Masons in a cornerstone ceremony.

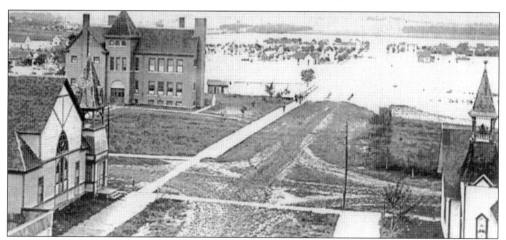

In 1927, Pender residents, to still Walthill objections, purchased for $30,000 this eight-room schoolhouse (built in 1895) to serve as the Thurston County Courthouse. Converting it to a courthouse involved partitioning rooms and placing the jail in the former manual training shop in the basement. Pender-born artist Don Trimble painted a picture of the courthouse along with two steepled churches. This photograph shows the Elkhorn River overflowing its banks. On the left is the former First Presbyterian Church (1892) and on the right, the old United Methodist Church (1886). (Courtesy of Norvin Hansen, *The Pender Times*.)

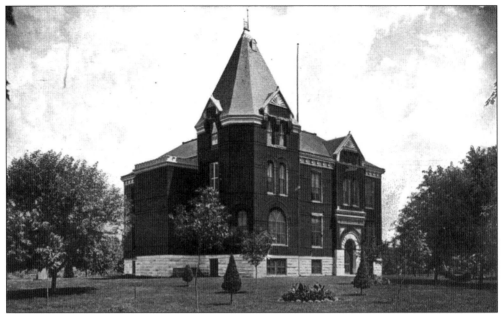

Nance County originated in 1879. Fullerton fended off challenges from Genoa and became the county seat. A rented schoolhouse served as the first courthouse. The courthouse, built in 1882, burned down in 1893. Voters approved a $17,000 bond in 1894. This courthouse, designed by W.C. Philips, was completed in 1895 at a cost of $20,000. Although built on a treeless pasture, many trees were planted. It was demolished when replaced in 1976.

This Gosper County Courthouse in Elwood, built in 1896, was financed with between $3–4,000 in fire insurance proceeds. It served until 1939. Elwood survived county seat relocation challenges from Smithfield in 1919–1921.

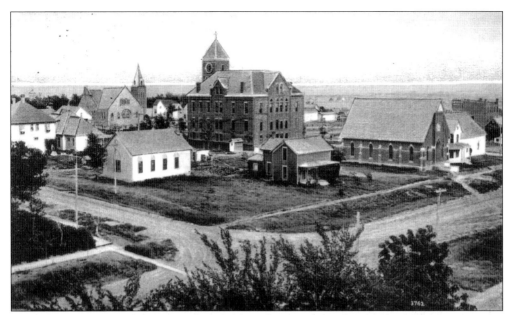

McCook (formerly called Fairview) in Red Willow County, defeated Indianola in an 1896 election, due in part to the arrival of the Burlington Railroad. The agitation on behalf of McCook lasted six years, involved corn whiskey at elections, and ended in a Nebraska Supreme Court ruling. Space was initially rented in the C.W. Meeker Building. This first courthouse in McCook, built about 1896, was razed in 1926 to make way for the current building. McCook was home to U.S. Senator George W. Norris (1861–1944) and former Governor and current Senator Ben Nelson.

Boone County, established in 1871, was named after Kentucky hunter and pioneer Daniel Boone. The county seat, Albion, is named after Albion, Michigan. The first courthouse, built in 1874, was, according to NACO, deemed inadequate, and the commissioners met in the Albion Hotel. This second courthouse, designed by Charles F. Beindorff of Omaha, on "Capitol Hill" in 1896, cost $28,000. Governor Holcomb spoke at the cornerstone laying, an ox was barbecued, and Albion played a ball game with Newman Grove. The building, completed in 1897, was replaced in 1976.

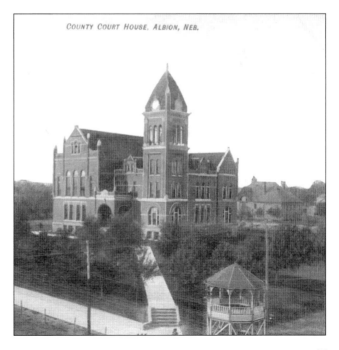

COUNTY COURT HOUSE, ALBION, NEB.

Rock County was formed in 1888 out of Brown County. Bassett prevailed as county seat over Newport, Rock Center, Thurman, and Tracy—after elections and a five-day trial. A fire from a gasoline stove in 1897 destroyed the 1889 frame courthouse, constructed with $5,000 in bonds. This second courthouse, funded in part by $3,920 in insurance, built in 1897 on the old foundation, followed the lines of the burned building, and served through the 1930s.

Wayne (formerly called Brookdale) became the Wayne County seat in 1882. The railroad went through Wayne but avoided LaPorte. The first wooden courthouse burned down on July 4, 1884. This Richardsonian Romanesque courthouse, designed by Orff and Guilbert of Minneapolis, cost $25,600 to $32,000. Built on donated land in 1899, the Nebraska Masonic Grand officers laid the cornerstone on August 3, 1899. Rapid work resulted in occupancy on December 28, 1899. Called the "castle in the cornfields" and referred to as a "national showplace," Goeldner hails the "especially fine corner towers."

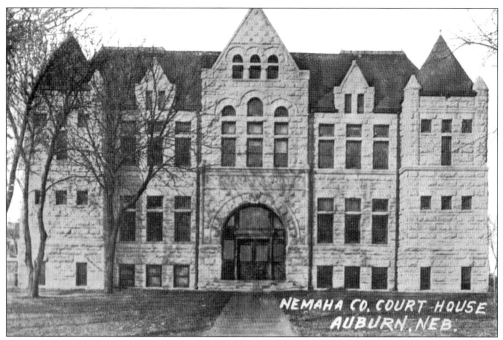

After several elections, Nemaha County voters passed a $40,000 bond issue in 1899 to build a new courthouse in Auburn. This Richardsonian Romanesque-style courthouse, designed by George Berlinghof, featuring local white limestone, opened in 1900. The basement served as the county jail. The modern street in front of the courthouse is made of red bricks.

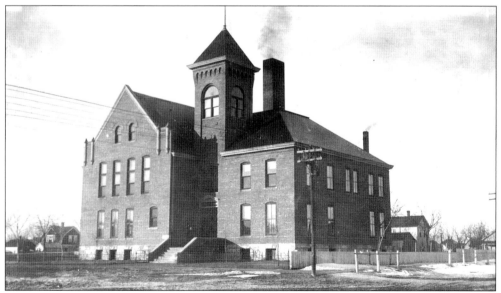

Cherry County voters approved a bond issue in 1900 to finance a new courthouse in Valentine. Designed by W.T. Misner of Omaha, it cost $13,979 and opened in 1901. It is similar to the adjacent 1904 Sheridan County building, also designed by Misner. The tower leaked in the 1930s. It became infested with insects and was removed in 1940. On the back of this postcard is the message, "Here is where Dad was County Judge 11 years."

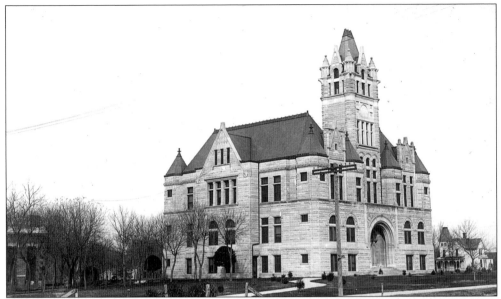

A new Thayer County Courthouse in Hebron was already under discussion before fire consumed the original 1877 structure. This courthouse, designed by George Berlinghof and built in 1902, cost $55,000. The carvings on the east entrance are attributed to Gutzon Borglum. A May 9, 1953 tornado inflicted $70,000 in damage. After heated debate the damaged clock tower and spires over the corners were removed.

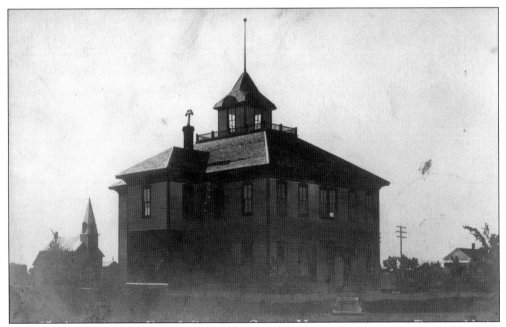

Boyd County was established in 1891, partly out of the Sioux Reservation, Dakota Territory. The first courthouse in Butte occupied a converted two-room drugstore. The building moved across the street to make way for this courthouse, dedicated in 1904. By 1941, the central tower with four windows had been removed, the widow's walk remained, and a nice stand of trees surrounded the building.

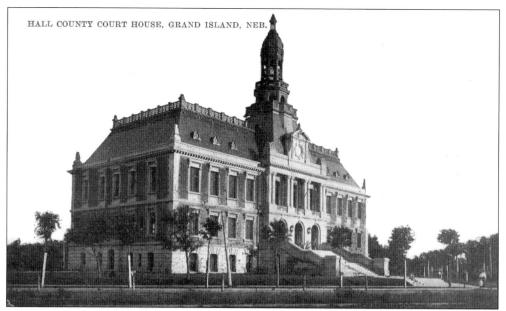

This Beaux-Arts-style Hall County Courthouse in Grand Island, designed by Omaha architect Thomas Rogers Kimball and completed in 1904, cost $115,000. Kimball's firm—with 871 commissions, including train stations, libraries, churches, and expositions–prevailed over George A. Berlinghof and four other architects. On the back, Mary wrote John: "Here is another one for you. This is a fine building, beats Geneva all to pieces. Went down to Opera House this morning and practiced." An Administration Building was built across the street in 1980.

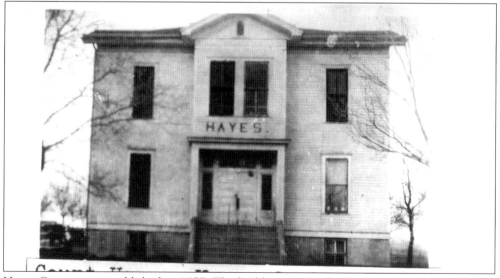

Hayes County was established in 1877. The buildings in the first county seat, La Forest, were moved to Hayes Center when that town defeated Estelle in an 1885 election for the county seat. County government in Hayes Center rented a private home for $10 a month. The initial courthouse burned in 1891. This larger courthouse, built in 1904, cost $5,000. According to *Nebraska, Our Towns*, the first Hayes county high school class graduated here. The building was replaced in 1954.

71

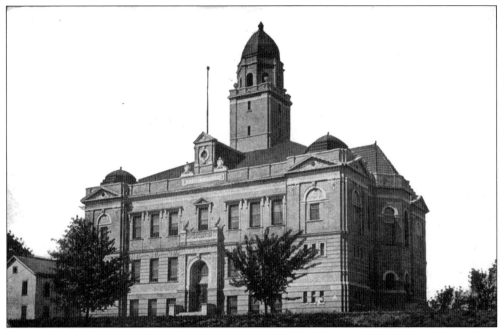

Though advocated as early as 1890, suspicion of Wahoo delayed building a new Saunders County Courthouse. In the 1890s, Mead offered $90,000 to the county to become the county seat. Wahoo rallied and passed a bond issue. The cornerstone of this brick $87,000 Romanesque Revival-style building, located high above the town, was laid in 1904. The outstanding features included steam heat, electricity, and murals in the hall.

Sheridan County was organized in 1885. County seat Rushville prevailed over Gordon, Hay Springs, and Clinton, perhaps because the sheriff stuffed the ballot box. The town of Sandoz is named for Jules Sandoz, father of the novelist Mari Sandoz, who among other books wrote *Old Jules*, that refers to county seat fights. County officials used rented space until a special tax funded this $17,325 courthouse, which was completed in 1904. Designed by W.T. Misner of Omaha, it is similar to that built next door in Cherry County in 1901.

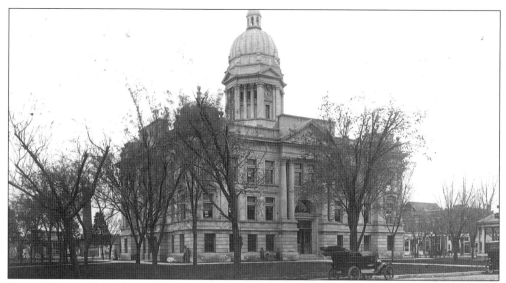

Seward County Courthouse drew its inspiration from the generosity of Lewis and Mary Moffitt, who sold land to raise money for the courthouse and jail, with the proviso that the courthouse cost not less than $100,000. It was funded in 1904 by a bond issue. Between 8,000 and 10,000 people attended laying the cornerstone on September 20, 1905. This Classical Revival-style building in limestone creates an imposing presence in Seward's town square. George A. Berlinghof designed it in the County Capitol form. Financing came from an $88,000 bond for the courthouse and $12,000 for the jail. All the money went to the courthouse, and the jail was built several years later. The Moffitts, founders of Seward, provided the square for the building and applied $30,000 of their estate to the cost of the structure.

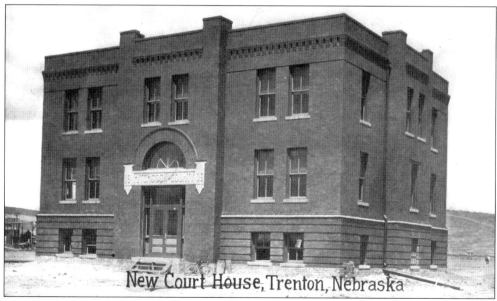

New Court House, Trenton, Nebraska

The Armitage building, which is now the Hitchcock County Museum, housed the first Hitchcock County Courthouse in Trenton, the county seat since 1893. This three-story courthouse, built in 1906, should be compared to the Keya Paha County Courthouse in Springview. That building was demolished, when replaced by a single-story structure in 1969.

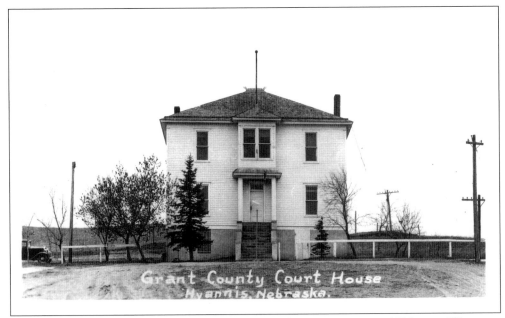

Grant County was created in 1887. Hyannis won the county seat in 1887 over Whitman. Bickering over the county seat delayed courthouse construction. An 1899 vote in favor of a mill levy did not lead to construction. In 1907, $4,500 was appropriated for this building.

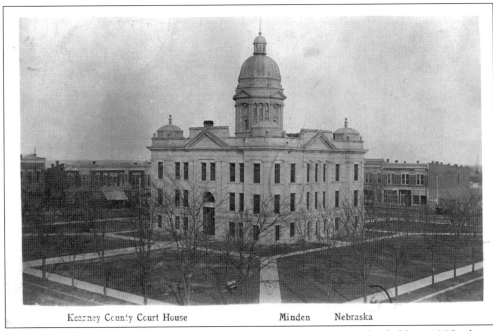

The Classical Revival-style Kearney County Courthouse in Minden, funded by a 1905 a bond issue, opened in 1907. The message on this September 7, 1908 postcard reflects the agricultural cycle, "I am going to make hay with three men tomorrow." Minden is called "The Christmas City" because in 1915 it started a 100-bulb electrical display. By the mid-20th century, it grew to over 10,000 lights.

Four

THE BUREAUCRATIC LOOK
1908–1929

The time for towers had passed. Courthouses in the 20th century accommodated automobiles rather than the horse and buggy. Electricity replaced gaslights, candles, and kerosene. The oldest courthouse in continuous use is in Nebraska City in Otoe County. Indoor plumbing and men's and women's restrooms replaced outdoor privies. Radiators, central heating and air conditioning, and dropped ceilings to obscure the ductwork replaced coal bins and stoves. Fire alarms and overhead sprinkler systems reduced the risks of conflagrations. Jails were relocated from the basement and top floor to separate buildings. The pine floorboards may still creak to the touch of a lawyer's shoe. Hitching posts were replaced by parking lots and parking meters. Telephone wiring, central switchboard, typewriters, and carbon paper were symbols of the burgeoning technology. Buildings that survived to the late 1970s had the lead paint and asbestos removed.

The edifices of the 20th century reflected the expansion of the judicial system and the transformation of the courthouse. The structures were now built for efficiency rather than emulating a grandiose European architectural style; they sought efficiency, authority and a businesslike atmosphere in a rectangular block. The courthouse, once the domain of the judge, clerk and county attorney, expanded in the 20th century to include probation, public defender, juvenile court, reconciliation, child support, workers compensation, and diversion programs.

This chapter introduces the Renaissance Revival, Neo-Classical, Beaux-Arts, and Second Renaissance architectural styles. These styles were also actively emulated in the 56 Carnegie Libraries built in Nebraska during this period. These buildings exhibited a solid and imperious demeanor, with columns adorning 24 of them.

This Blaine County Courthouse in Brewster, built in 1908 of cement blocks for $1,000, replaced the courthouse that burned down in 1907. From 1967 onward there have been additions and remodeling. This 1998 photograph reveals modifications to the windows and the introduction of air conditioning. (Courtesy of Jean Ann Teahon, Blaine County Clerk.)

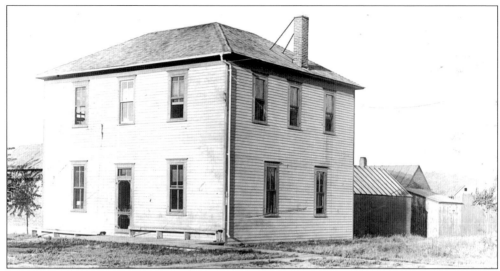

In 1902, after five elections, Center prevailed over Niobrara as the Knox County seat. Twenty-five wagon teams were used in the move. This frame courthouse, dating from 1909, has a brick vault in the back. One and two-story additions were built, including a men's and women's jail. The women's jail was sold, moved onto Main Street, became Mary's Cafe, and was later torn down. (Information courtesy of Judy K. Carlson, Knox County Deputy Assessor.)

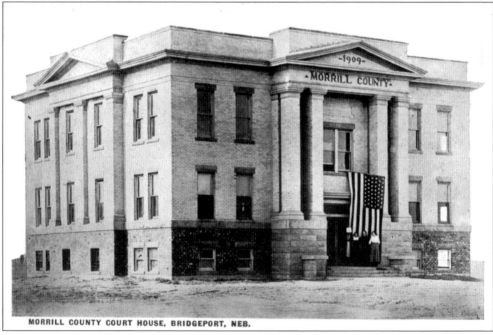

MORRILL COUNTY COURT HOUSE, BRIDGEPORT, NEB.

Morrill County, originally part of Cheyenne County, was established in 1908 with Bridgeport, settled in 1900, the county seat. Lincoln Land Company donations and a bond issue of about $15,000 financed this Classical Revival-style courthouse, designed by J.P. Eisentraut of Kansas City. Completed in 1910, a 1921 history calls it a "magnificent court house." According to *Nebraska, Our Towns*, "It is one of the few original courthouses remaining in the state." Morrill County also contains Courthouse Rock.

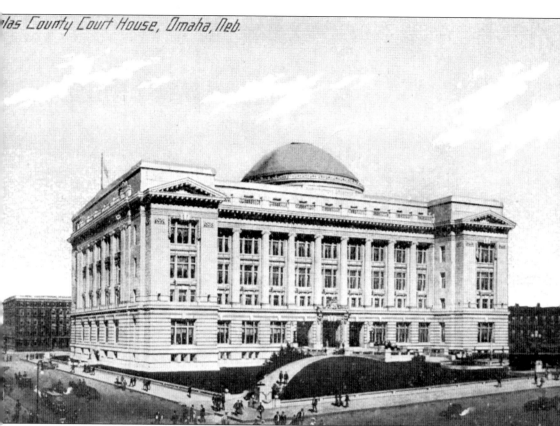

This Douglas County Courthouse is considered an "outstanding example of the Renaissance Revival Style," and a "mature and triumphant work" of its designer, John Latenser. Built between 1909 and 1912 the building has a well-decorated interior and murals adorn many of the courtrooms and the dome. While the exterior has remained stable, the interior has been frequently reconfigured to accommodate changing needs. A riot on September 28, 1919, resulted in a lynching of African-American Will Brown, and fire damage to the building. James Joyce's statement in *Ulysses*, "black beast burned," may have referred to Omaha. The lawn, once the location of the 1882 courthouse, is used as an experimental plot for the extension service, and the Salvation Army sets up annually in December a lit sign indicating the rising level of charitable pledges. The interior has a five-story atrium covered by a dome enclosed in an eight sided cover. The National Register for Nebraska defines Renaissance Revival which flourished from 1900 to 1920 thus: "The style is characterized by formalism in plans, raised basements, low hipped roofs covered with clay tiles, symmetrical facades with wide overhanging eaves, arched entries and second story porches. Window treatments vary from story to story and are flat or round arches." (Courtesy, Historical Society of Douglas County.)

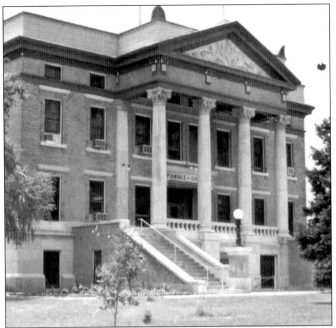

Pawnee County voters approved an $85,000 bond issue in 1910. This limestone and brick Classical Revival-style courthouse, designed by W.F. Gernandt of Fairbury, with cornerstone laid by the Grand Lodge on October 24, 1911, opened in the same year. The jail is on the third floor. The building also has a basement. Pawnee City is one of 12 Nebraska towns, 11 of them county seats, to have a New Deal-era Post Office with interior paintings sponsored by the New Deal Federal Art Project of the Works Progress Administration.

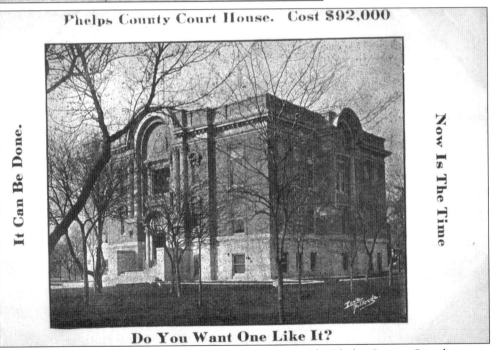

Phelps County Court House. Cost $92,000

It Can Be Done.

Now Is The Time

Do You Want One Like It?

Postcards were frequently employed in political campaigns. The Phelps County Courthouse, in Holdrege, designed by W.F. Gernandt and built in 1910, cost about $107,000. This postcard, postmarked Tekamah, August 28, 1912, urged Burt County citizens to build an up to date courthouse. Burt County voted in 1914 to accept a tax levy to fund a Beaux-Arts building that opened in 1917. The promoters on the reverse side of the card proclaimed Burt County the "Banner County in Nebraska," although the actual Banner County with its county seat in Harrisburg had been formed in 1888.

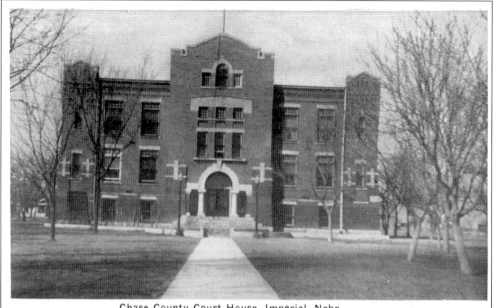

Chase County Court House, Imperial, Nebr.

This brick and cement Chase County courthouse in Imperial, built in 1911, replaced the burned-down courthouse. On the back of this card is the message: "Yes I collect all cards of buildings, odd happenings, etc. Do you? This was taken years ago. Now they have the loveliest lawn. The County jail is left corner. All county business is transacted in this building."

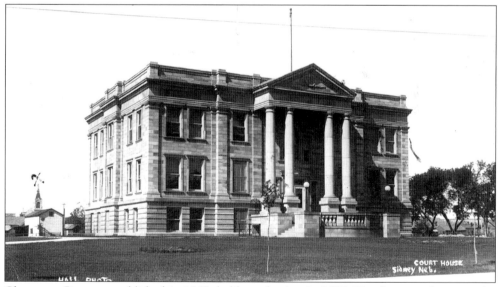

Cheyenne County, established in 1867, held an election in 1870. The first courthouse in the county seat of Sidney was at the Fort Sidney Suttler's Store or Post Exchange. It was followed by a cement block construction, later used as a rooming house. The pictured courthouse, built during 1911–1914, cost $50,000. A 1921 history reports, "The restroom in the northwest corner of the basement, maintained by the Women's Club, is cozy, comfortable and convenient and is free to all the women of the county." The building, "a constant source of pleasure to the eyes and satisfaction to the people," was replaced in 1967.

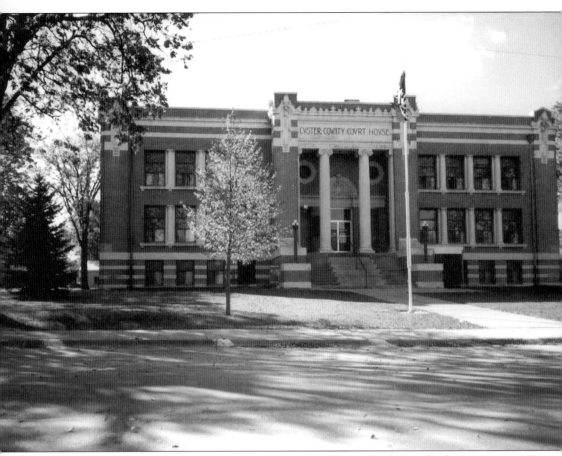

Broken Bow's Custer County courthouse, in the Neo-Classical style popular from 1900 to 1920, was built on the site of its burned down predecessor. It was dedicated April 15, 1912, and cost $55,007. The Omaha architect, John Latenser, created a fireproof structure. The National Register for Nebraska defines Neo-Classical Revival, which flourished from 1900 to 1920 as follows: "Front facades are usually dominated by a full-height porch with the roof supported by classical columns. Symmetrically arranged buildings show monumental proportions, balanced windows, and a central entry." (Courtesy of Larry A. Hickenbottom, Custer County Supervisor, District 2.)

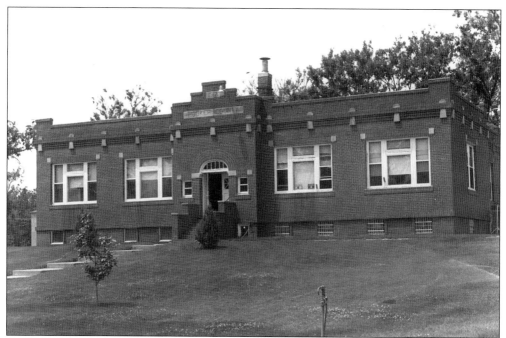

This two-story brick Hooker County Courthouse in Mullen was financed by a $15,000 bond issue, passed in 1911. Built in 1912, it cost $12,200. A drilled windmill pump stood on the corner of the property. (Courtesy of Marshall Tofte, Nebraska Association of County Officials and *Hooker County Tribune*.)

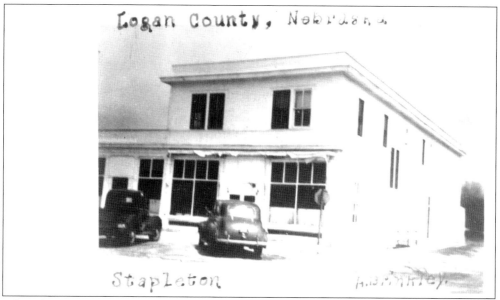

After almost 20 years of discussion, Stapleton replaced Gandy as the Logan County seat. A special courthouse election in 1929 was resolved by the courts in 1930. This was the last change of a county seat in Nebraska. Records were moved from Gandy to Stapleton's Farmer's State Bank and Nicholas Hotel, built in 1912. The Nicholas Hotel became the courthouse and also housed the library. This building burned down in March 1962.

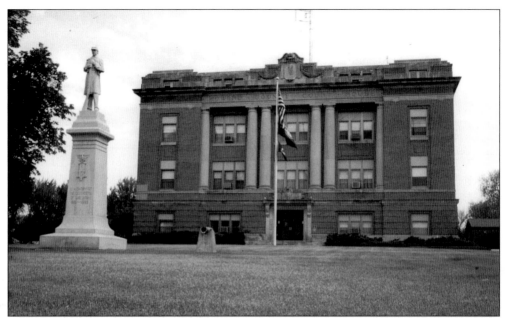

Over 6,000 people attended the all day affair of laying the cornerstone of this Classical Revival-style Howard County Courthouse, built from Bedford stone, in St. Paul on June 5, 1913. According to Ellen Kiechel Partsch, the big attraction, an airplane demonstration, flopped as it only taxied on the ball field. According to NACO, the Grand Army of the Republic occupied one of the first floor rooms for awhile. (Courtesy of Nebraska Newspaper Project.)

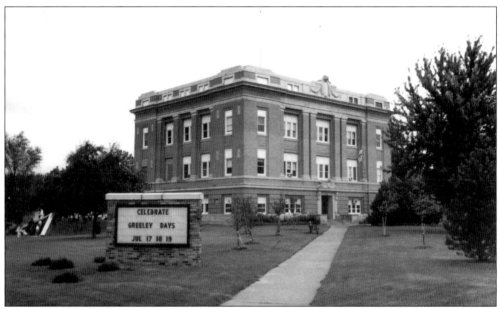

In 1907, Greeley County decided to replace its two-story brick building in Greeley. A 1913 election authorized a new courthouse by a margin of one vote. This Classical Revival-style courthouse was designed by George Berlinghof and financed by bonds. They set the cornerstone in June 1913, and completed the building in 1914 at a cost of about $85,000. (Courtesy of R. Mlinor, Greeley County Historical Society.)

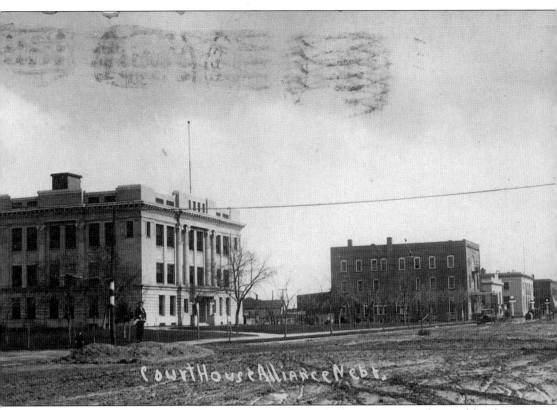

CourtHouse Alliance Nebr.

The Beaux-Arts style Box Butte Courthouse in Alliance, built in 1913, was designed by the Kansas City firm Rose and Peterson. Financed by a bond issue and $65,000 it sits on the site of the old courthouse. County Commissioners acquired architectural ideas visiting courthouses outside of Nebraska. The dome has stained glass, the floor contains the Great Seal of Nebraska in marble. The original 1914 electrical wiring was replaced in 2000. The National Register for Nebraska defines Beaux-Arts, a style from 1900 to 1910: "This classical style is identified by large masonry buildings with symmetrical facades and an abundance of decoration and a variety of surface finishes. Projecting porches with roofs supported by classical columns, often grouped in pairs, are typical. Flat roofs, pronounced cornices, raised entries, and arched openings are other common features."

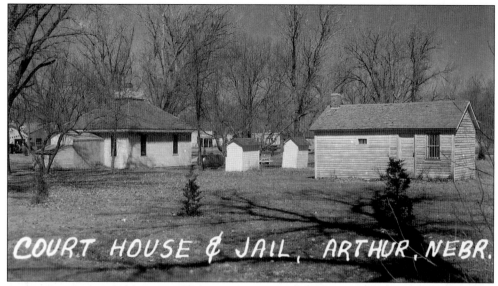

Arthur County seceded from McPherson County in 1913. This courthouse in Arthur was built in 1914 and the jail the following year. Both are one-story and made of wood. The 26 x 28 ft. building cost $900, qualifying for entry in Ripley's *Believe it or Not* as the smallest courthouse in the United States. The courthouse has been described as a "shack." It had no water supply, plumbing or indoor toilets. It was wired for electricity in 1925. The old courthouse and jail, replaced in 1961, now serve as the County Museum.

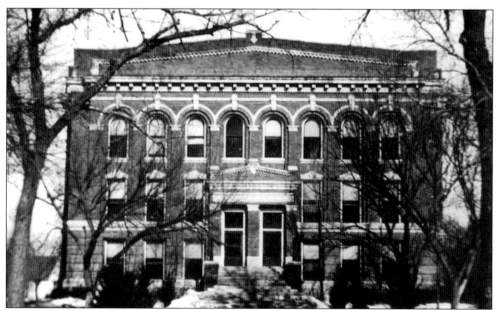

This second Webster County Courthouse in Red Cloud, a three-story Second Renaissance Revival brick structure designed by W.F. Gernandt, cost $46,786. The cornerstone was laid in July 1914. It features in Willa Cather's 1922 Pulitzer Prize-winning novel, *One of Ours*, where she wrote, "One bright June day Mr. Wheeler parked his car in a line of motors before the new pressed-brick Court house in Frankfort. The courthouse stood in an open square, surrounded by a grove of cottonwoods. The lawn was freshly cut, and the flower beds were blooming."

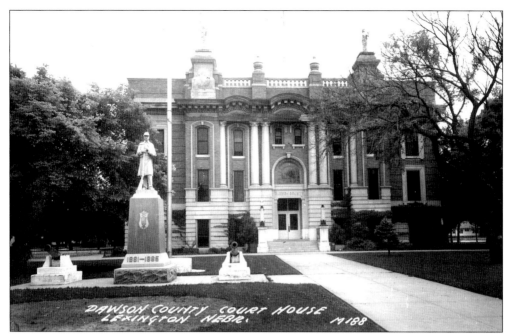

The Dawson County Courthouse in Lexington, funded by voters in 1912 and completed in 1914, replaced a 1874 wooden structure. Designed by William F. Gernandt and built in the Beaux-Arts style, this fireproof structure contained Georgia marble and terrazzo flooring. It cost about $100,000 and used Bedford Rock from Indiana. There are statues to "Liberty" and "Justice" as well as war memorials.

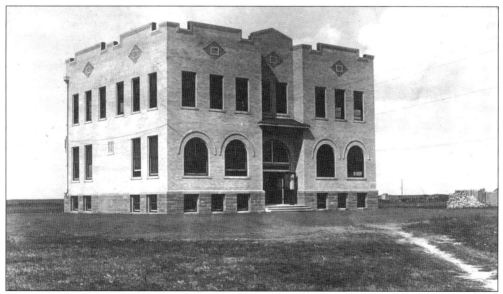

This Keya Paha County Courthouse in Springview, built by O.A. Shipley in 1914, cost $55,000. Its style is similar to the Hitchcock County Courthouse in Trenton built in 1906. Multiview postcards, (several images on the card), a popular "Booster" genre, often included courthouses. A Springview multiview proclaimed it "The best Inland town in Nebraska" while a Holdrege, Phelps County multiview proclaimed it the "Queen City of Western Nebraska."

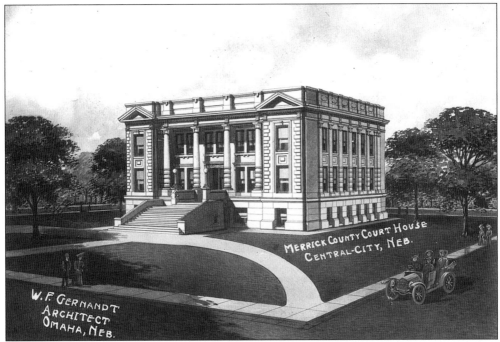

Merrick County approved a new courthouse in Central City in 1911 and this Classical Revival-style courthouse was completed in 1915. This is an architect's sketch of the courthouse. William F. Gernandt, the architect, designed many Nebraska courthouses between 1910 and 1923.

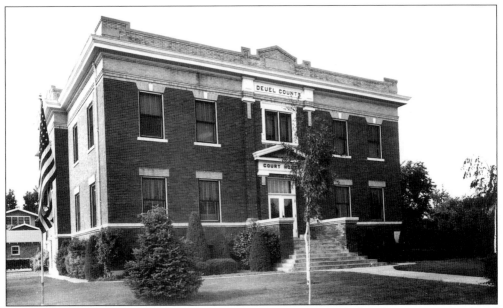

Chappell became the Deuel County seat in 1894. Voters approved a bond issue in 1915 to build a new courthouse and jail to replace the original smaller buildings. This Classical Revival-style building was completed in 1915. According to *Nebraska, Our Towns*, it is built on the site of "The small building that had served the area during its stormy organizational days."

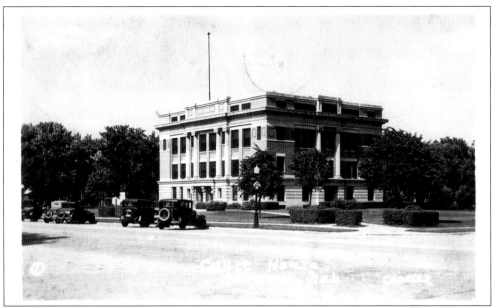

This is the Burt County Courthouse in Tekamah. Plans for this Beaux-Arts building date from 1913. In 1914, county residents voted to accept a tax levy to finance the building. Construction started in 1916 and the building opened in 1917. The cornerstone records the involvement of the Grand Lodge of Masons. The jail on the fourth floor has been condemned. A dramatic terrazzo-tile seal adorns the floor at the entry of the building.

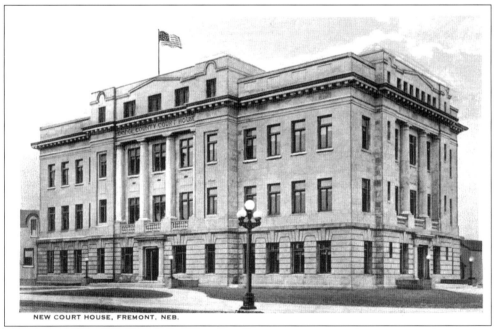

NEW COURT HOUSE, FREMONT, NEB.

This is the third Dodge County Courthouse in Fremont. It occupies the same ground as the first and second buildings. This Classical Revival-style or neo-classical revival structure, designed by A.H. Dyer and Co. and built by Olson and Johnson of Missoula, Montana, cost $119,675. Built in 1917, it was dedicated in 1918.

This Wheeler County Courthouse in Bartlett, built in 1920 on the same site as that of the courthouse, burned in 1917. The current 1982 building was built next to the old courthouse, which was recycled into a museum. (Photo courtesy of Nebraska Newspaper Project.)

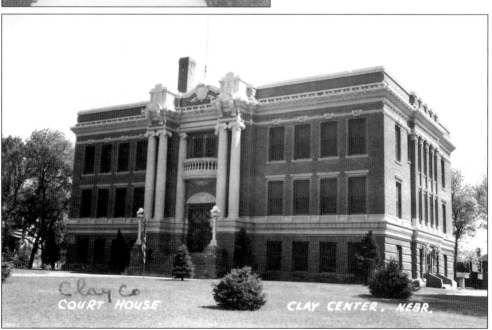

The Clay County Courthouse in Clay Center was inadequate by 1916. The County Board levied a special tax for a third structure. The Masonic Lodge laid the cornerstone of this Beaux-Arts building. The doors opened for business in 1921. The message on the postcard stated, "Here is our Clay Court House. I'm not so particular what kind of view card I receive in turn."

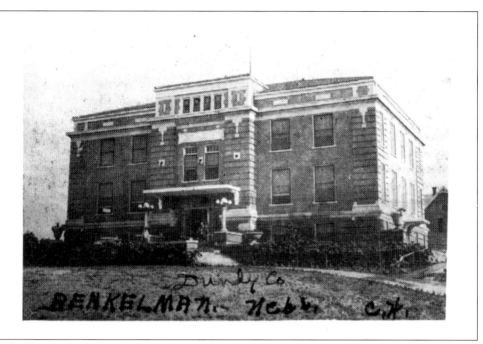

Dundy County had proposed a new courthouse in Benkelman as early as 1911, but a poor agricultural economy and the First World War delayed funding until 1920, when voters approved a bond issue. Designed by A.T. Simmons, it cost about $61,000. A small copper box time capsule contained a Holy Bible and various documents about Freemasonry. The courthouse opened in 1921.

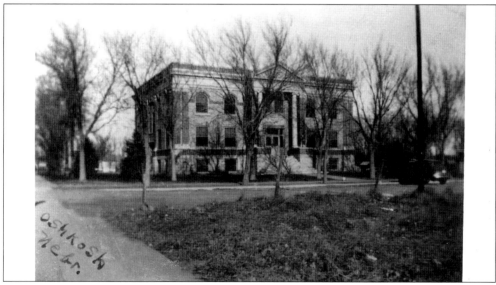

Garden County divided from northern Deuel County in a November 1909 election. The county seat is Oshkosh. Court was held on the first floor of the Commercial Hotel. In 1914, a $40,000 bond for a new courthouse failed despite the county offices being rented in an "old cramped" and "unsuitable building." A successful 1921 bond issue financed this Classical Revival-style building.

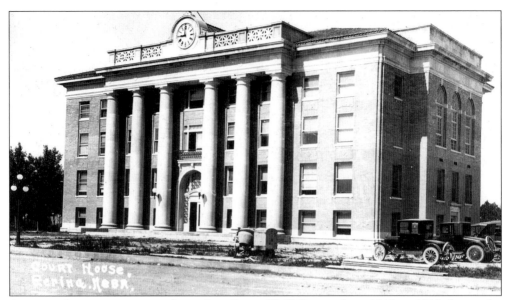

A court relocation movement brewed in Scotts Bluff County from 1910 to 1919 due to the better rail service to Scottsbluff, but Gering prevailed. In 1919, voters approved a bond issue for this Classical Revival-style building in Gering. After some dispute regarding location and acquiring the land, the cornerstone was laid in October 1920. The building opened in 1921.

This Beaux-Arts style Sherman County Courthouse in Loup City, financed by a special tax levy commenced in 1916, raised $102,640 by the time the building was finished in 1921. It was designed by Henningson Engineering and built by John Ohlsen and Sons. (The Ohlsen Brothers Brickyard produced bricks from 1887 to 1912). The tan brick building with terra cotta trim was dedicated on October 8, 1921. (Courtesy Sherman County Clerk.)

A 1919 bond issue financed this Beaux-Arts-style 101 x 78 ft. three-story building in Ord, Valley County. Designed by W.F. Gernandt, who was responsible for about 20 courthouses, it was completed in 1921 at a cost of $234,855. The local newspaper proclaimed, "The district court room is to be the finest ever built." *Scratchtown: A History of Ord, Nebraska* by Ronald J. Radil describes the contents of the time capsule in the cornerstone.

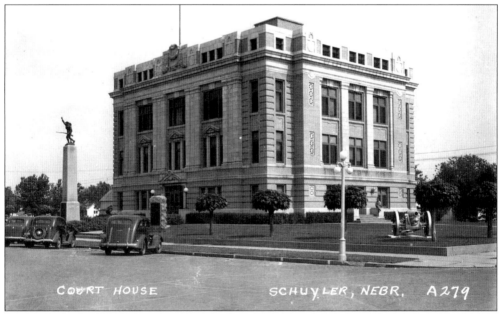

George A. Berlinghof designed this Second Renaissance style Colfax County Courthouse in Schuyler, built in 1921-22 for $210,000. He also designed the Seward County Courthouse. The National Register for Nebraska defines Second Renaissance Revival, which flourished from 1900 to 1920 thus: "Recognized by the large scale and size, these buildings are organized into distinct horizontal divisions, with each story finished in a different fashion. Flat and arched openings, massive cornices, and roof balustrades (railings) are often employed."

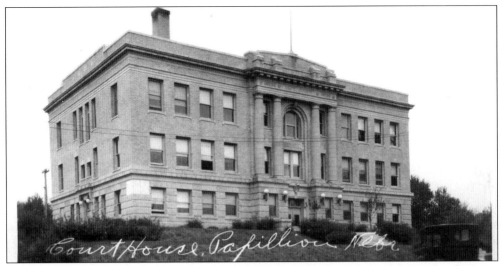

An overwhelming three to one majority approved building this Classical Revival-style Sarpy County Courthouse in Papillion. W.F. Gernandt designed the building and it cost $150,000. The cornerstone was set on July 4, 1922, and the building opened in 1923. When the new courthouse opened, this building became the Papillion City Hall, a position it still holds.

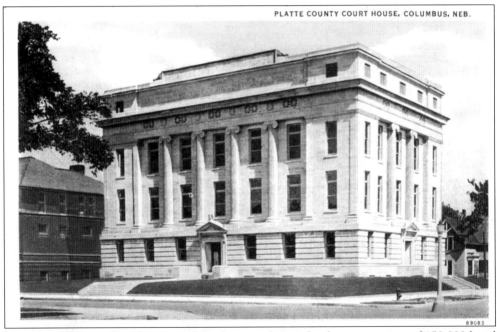

This Platte County Courthouse in Columbus was the result of voters passing a $150,000 bond issue and a $70,000 tax levy in 1917. Columbus architect Charles Wurdeman designed this Classical Revival-style building. War delayed construction and it was dedicated in June 1922. The District Court had "just the proper acoustics," the building was "heavily insulated with asbestos," and it would "serve the needs of the people of Platte County for generations to come." The National Register of Historic Places nomination notes, "It is the second of six entirely stone-faced County Citadels built between 1917 and 1930 across the State." A $1.76 million addition was completed in 1976.

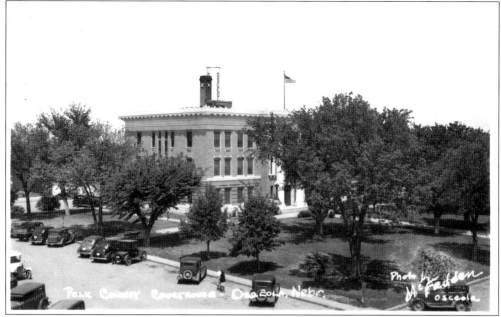

This Beaux-Arts-style Polk County Courthouse in Osceola opened in 1922. Women voting led to a legal challenge of the bond election. According to *Osceola, 1871–1971*, W.F. Gernandt, an Omaha architect, wanted the building to have classic lines, in modern renaissance style, and "free from the old time objectionable tower or dome…now considered an expensive and useless ornament." He wanted to build the "most up-to-date county building."

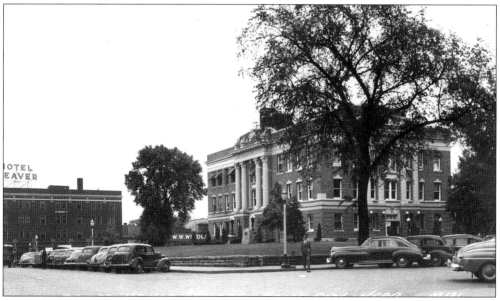

This Classical Revival-style Richardson County Courthouse in Falls City, also designed by W.F. Gernandt, started in 1923 and completed in 1925, replaced the initial building destroyed in a fire. Fire proofing it cost about $200,000. Masons planned the cornerstone laying ceremony and the American Legion Post directed the April 1925 dedication. It had a Masonic hall upstairs. Repairs in the early 1980s, including stabilizing the waterlogged roof, cost $277,000.

This is the Thomas County Courthouse in Thedford, financed by a bond issue and completed in 1924. The prior courthouse had burned down, and as in the fire destruction of the Thayer Courthouse in Hebron, other towns tried to wrest away the county seat. Thedford prevailed against Seneca and built a 12 x 24 ft. wooden building to serve in the interim. (Photo courtesy of the Nebraska Newspaper Project.)

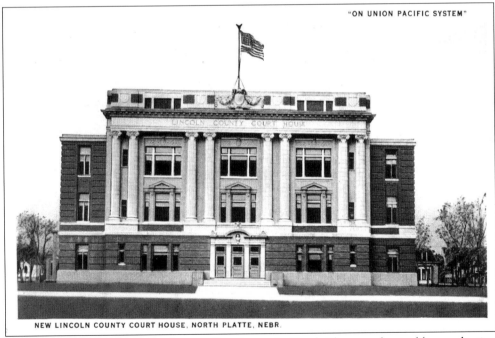

"ON UNION PACIFIC SYSTEM"

NEW LINCOLN COUNTY COURT HOUSE, NORTH PLATTE, NEBR.

This Beaux-Arts-style Lincoln County Courthouse in North Platte, authorized by an election in 1919, was completed in 1924. Designed by George Berlinghof, it cost almost $400,000. It was already under construction when the old courthouse became a victim of arson. On the back of the postcard is written, "This is the picture of the place I work and is a very pleasant place."

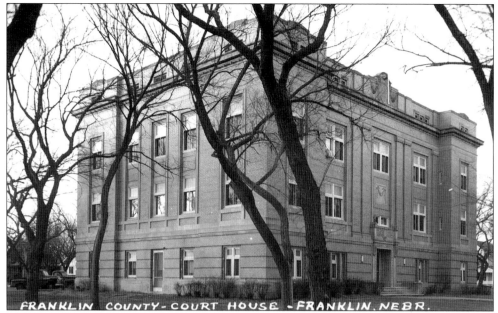

FRANKLIN COUNTY-COURT HOUSE -FRANKLIN, NEBR.

Franklin challenged Bloomington several times for the county seat and finally prevailed in October 1920. The county rented space while acquiring land and funding for a new building. Vrana Brothers of Omaha built this Classical 96 x 69 ft. Revival building, designed by George A. Berlinghof. Construction began in 1925 and it opened in 1926.

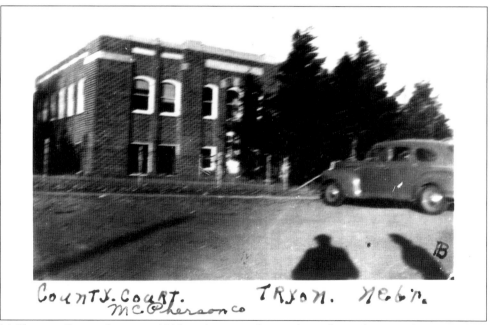

County. Court. McPherson Co TRYON. NEBR.

McPherson County began in 1916 to discuss replacing the sod courthouse in Tryon. Voters failed to approve a $4,000 bond but did approve in 1920 a special five-mill building levy to build a new two-story brick courthouse, started in 1925, completed in 1926, and dedicated in September 1927. The insufficient tax revenues necessitated a $6,000 bond to complete the building, install heat, and purchase furniture.

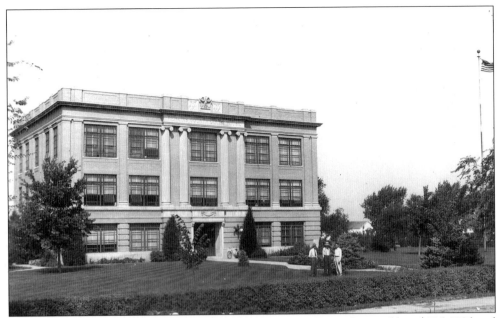

This Classical Revival-style Perkins County Courthouse in Grant, financed by a $125,000 bond issue (approved in 1926 by a vote of 942 in favor, 139 against), opened in 1927. Subsequently, ceilings were lowered, and air conditioning and carpeting were added.

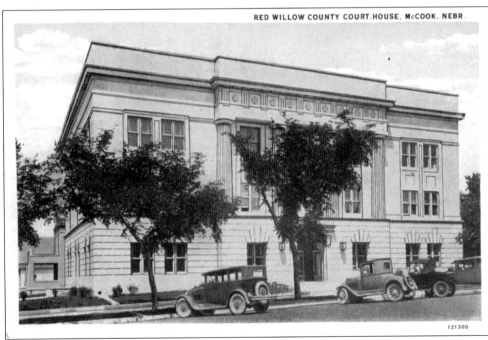

RED WILLOW COUNTY COURT-HOUSE, McCOOK, NEBR.

In 1926, Red Willow voters approved a bond issue to build a courthouse designed by Marcus L. Evans "sufficient in all respects at the time for the demands of the county." The Classical Revival-style building in McCook, completed in 1927, was "modest, pleasant and imposing." Extensive $638,945 remodeling (1989–93) financed an elevator, carpet, dropped ceiling, and central heating and air-conditioning. Courthouse rededication occurred in 1993.

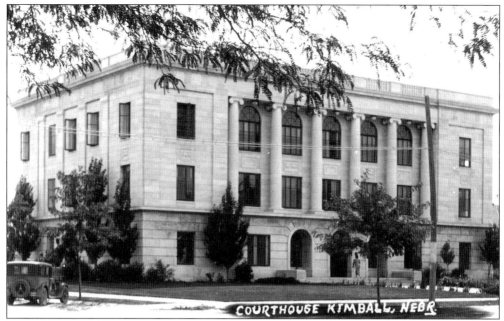

This Classical Revival-style Kimball County Courthouse in Kimball was completed in 1928 and cost about $180,000. The building was constructed of Carthage stone with floors of Ozark gray marble. The furnishings are in American walnut, a strong competitor with oak. The writer wrote, "This is a very pretty building. The grounds around are beautiful."

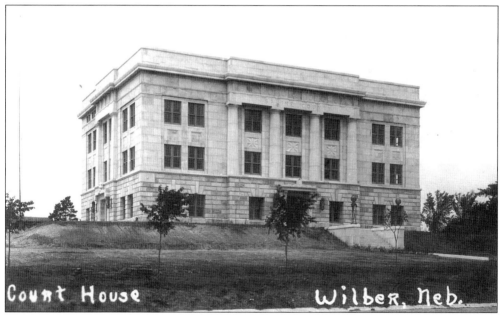

This Saline County Courthouse in Wilber was officially described as "modest, pleasing and imposing." The second floor contained the courtroom; "a more somber, dignified tone pervades the corridors...placing sheer architectural beauty with quite, artistic dignity." Including a new jail it cost $267,828. The American Legion participated in laying the cornerstone on June 5, 1928.

Hall County Treasurer's Office.

GRAND ISLAND, NEB OCT 13 1898 189

Statement of Taxes for the Year 1898.

Description of Property —or— Name of Town.	Sect'n or Lot.	Town or Block.	Range.	Total	
Lots 1 & 2 Isl assessed to June Sheldon				7	53
" 6 & 7 in 88 " " J M "				6	84
		6	9 M	14	37
The 1897 tax is paid					
	Rec'd				

PERSONAL CHECKS NOT ACCEPTED.
See if above descriptions are correct.
Return this card when paying tax.

WM. THOMSSEN, Treasurer·

This 1898 Hall County Statement of Taxes, a mill levy on the assessed valuation of real property, land, buildings, and farmlands, was the major source of county government revenue before the introduction of sales, gasoline, personal and corporate income tax. The County Treasurer maintained these records.

Sample Ballot

Official Disabled Ballot

The County of Keith
In The State of Nebraska

Special Courthouse Bond Election
Tuesday, November 8, 1960

...

Shall the County of Keith in the State of Nebraska borrow Two Hundred Fifty Thousand Dollars ($250,000) and issue its negotiable bonds in the principal amount of Two Hundred Fifty Thousand Dollars ($250,-000) for the purpose of erecting a suitable Courthouse in the County, the bonds to be dated when issued and become due in not to exceed twenty (20) years after date and bear interest at such rate as the County Commissioners may determine at the time of their issuance, payable one year after date and semi-annually thereafter, and

Shall the County of Keith in the State of Nebraska levy annually a tax on all property in the County, except intangible property, sufficient in rate and amount to pay the interest and principal of said bonds as the same become due?

☐ YES 2459

☐ NO 1301

In this Special Courthouse Bond Election ballot from 1960, Keith County asks the electorate for authority to issue $250,000 in bonds and to levy an annual tax to pay the interest and principal. It passed, the vote being 2,459 to 1,301. (Courtesy of Jack Pollock, *Keith County News*.)

Five

THE DEPRESSION &
FEDERAL ASSISTANCE

The November 1929 stock market crash ushered in the Great Depression. Nebraska, an agricultural state, was also struck by drought. Private enterprise, capitalism, and voluntary effort were joined by New Deal projects to provide employment and improvements to the infrastructure. Schools, roads, bridges, hospitals, sewage disposal plants, and courthouses are the most visible architectural reminders of the impact of the New Deal on our built environment. The New Deal through the Public Works Administration (PWA) and the Works Progress Administration (WPA) provided federal revenues to get people back to work. According to Marian M. Ohman, by 1938, 323 courthouses and city halls had been authorized, and Arthur Schlesinger stated that between 1933 and 1939 about 65 percent of courthouse construction received federal assistance.

Nebraska built seven new courthouses between 1930 and 1940. Substantial expansions occurred in Otoe County, Nebraska City, in 1936-37, and Dixon County, Ponca, in 1940 (pictures on pages 20 and 37). Remodeling also occurred in Madison, Pierce, and Blair. The WPA provided Omaha's Douglas County Courthouse $38,087 for renovation in 1940.

This chapter introduces the Art Deco architectural style. The federal presence and its architectural style were both novel. These buildings are functional, less adorned than their predecessors, and there is an almost complete absence of columns. The Masonic order according to Ohman still participated actively in the cornerstone ceremony with the stone square, level, and plumb anointed "with corn for plenty, wine for joy and gladness, and oil for peace."

A bond issue passed by the voters in 1930 led to the construction in 1931 of this Classical Revival-style Sioux County Courthouse in Harrison. Designed by E.L. Goldsmith Co. it has Italian marble on the floors and stairway and cost $100,000. The copper box in the cornerstone included records from the Catholic, Lutheran, Methodist, and Christian Science churches. Compare the detailing around the windows to the Sherman County Courthouse built in 1921. (Photo courtesy of Beth Irwin, Omaha, Nebraska.)

This Knox County Courthouse in Center dates from 1934. Called "a mighty slab of concrete" it consumed 800 sacks of cement and four times as much gravel to create its 2 1/2 to 16-inch-thick construction. Funding came from a small tax, the Civilian Works Administration, and the Federal Emergency Relief Administration. County prisoners made 130,000 "cement bricks." The Veterans Monument is behind the handicap parking sign. A 1988 Annex houses Social Service and County Extension programs. (Photo courtesy of the Nebraska Newspaper Project.)

In 1935, Holt County qualified for a Federal Emergency Administration of Public Works grant, which resulted in the construction of the Art Deco-style courthouse in O'Neill, funded by $61,000 in bonds. The building, designed by John Latenser and Sons and built by Peter Kiewit in 1936, cost $81,890. Asked about noteworthy features, someone responded, it "looks similar to all other courthouses built in this period."

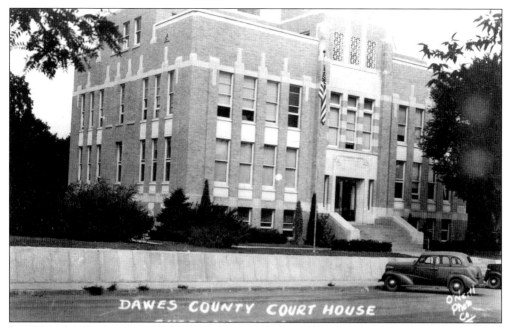

In 1935, the Dawes County Commissioners and the Public Works Administration (PWA) cooperated to build this Art Deco-style courthouse in Chadron that opened in 1937. The National Register for Nebraska defines Art Deco as Modernistic flourishing from 1930 to 1940: "Art Deco, the earlier Modernistic phase…is characterized by angular composition, with towers and vertical projections and smooth wall surfaces with stylized and geometric motifs, including zigzags and chevrons."

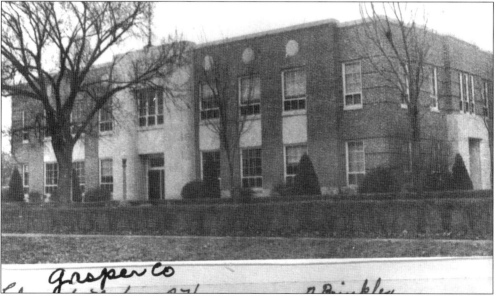

This is the fourth Gosper County Courthouse. The Public Works Administration offered 45 percent of the cost of public buildings. County voters approved a $42,000 bond issue. This courthouse cost $78,000. The courthouse in Elwood, designed by McClure and Walker of Kearney, was built in 1939. The November dedication included a barbeque lunch.

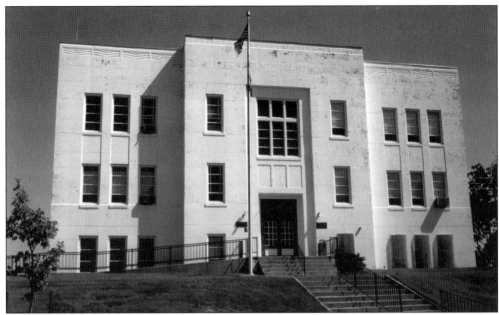

Local citizens of Rock County approved a $17,000 bond issue, which in combination with a $33,000 federal Public Works Administration grant, started construction of this Art Deco-style courthouse, one of four in the state, in Bassett in 1939. Completed in 1940, it stands on the site of the former courthouse. (Photo courtesy of the Nebraska Newspaper Project.)

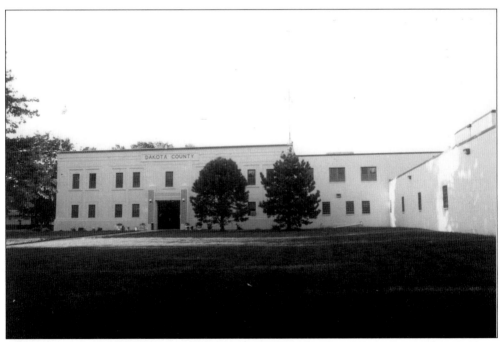

This, the second Dakota County courthouse in Dakota City, built in 1940 with WPA backing and finished in white cement, cost $66,000. A 1975 addition on the right side contains a jail, district courtroom, and elevator. In the 1980s, the high cost of heating and cooling led to the installation of energy efficient windows. (Photo courtesy of Oliver B. Pollak.)

Six

THE ARCHITECTURE OF DE-EMPHASIS 1946–PRESENT

By the end of the Second World War, the growth in population and complexity in the economy was matched by a growth in Federal, state, and local government regulations and responsibilities. Old courthouses were straining under the accumulation of records, the expansion of the number of judges and cases, and the propensity to litigate and appeal. The deterioration of buildings tested the ability to accommodate the people's business, presenting the alternatives of patience, modernization, or replacement. Plumbing, electricity, gas, security, fire alarms, up to code construction, and public pride resulted in several new courthouses. Architectural style was governed by function and economy. Adequate parking appeared more important than grandeur.

New courthouses, additions, annexes, administrative buildings, jails, now called correctional centers or facilities, and remodeling existing structures from Douglas County in the east to Scotts Bluff County in the west were symptomatic of county attempts to accommodate expanding courthouse business. Decades of civil, probate, and criminal cases created an unimaginable paperwork mass filling storerooms, basements, and offsite storage. Microfilm, microfiche, and electronic scanning offered some relief. Security, metal detectors, closed circuit, and reporter's television cameras became ubiquitous. County law libraries were enhanced by connecting to the Internet and the World Wide Web as many legal resources became available electronically. Word processors and photocopy machines replaced typewriters and carbon paper.

Luebke observed that Nebraskans "prefer to retain institutional inefficiency rather than to consolidate or reorganize these relics of frontier optimism." Nonetheless, Omaha and Lincoln, in Douglas and Lancaster County, share office space. Numerous small school districts have been consolidated. Libraries have regional centers. And, 911 emergency services are working a new grid work, transforming Rural Routes into genuine street addresses. This chapter introduces one Prairie-style building and a number of low-slung, single-story extended ranch style buildings.

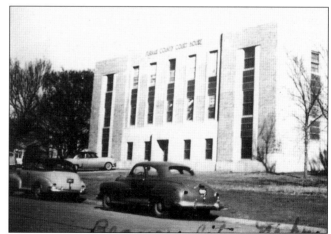

This Furnas County Courthouse in Beaver City was financed by $200,000 in bonds. The Masonic Grand Lodge of Nebraska laid the cornerstone in November 1949. Dedicated on May 4, 1951, it is built on the site of its predecessor. (Courtesy of Judy A. Beins, Clerk, Furnas County District Court.)

The Cuming County Courthouse in West Point, designed by B.H. Backlund of Omaha and built in 1954, stands to the rear of the old courthouse. Voters in 1948 approved financing through an increased mill levy by a margin of three to one. Within five years, they raised about $313,000. They broke ground in 1953, occupied it in December 1954 and dedicated it in 1955. The building has some hints of Prairie Style, according to the National Register for Nebraska, a movement popularized by Frank Lloyd Wright that "emphasized the integration of building and its site. Elements of the style include a low-pitched roof line with over-hanging eaves, two stories high with a one-story porch, and an overall horizontal emphasis in the design." (Photo courtesy of Gerard E. Mick, Omaha, Nebraska.)

This brick Hayes County Courthouse in Hayes Center was dedicated in 1954. The population of Hayes County is just over 1,000. (Courtesy Marshall Tofte and Nebraska Association of County Officials.)

In 1954, Cherry County built a courthouse annex in Valentine designed by John Latenser and Sons of Omaha. It stands next to the old courthouse. The building contains the county jail; the jail in the 1901 courthouse having been condemned by the fire marshal. Design problems in the new building resulted in the old courthouse continuing to provide the courtroom. (Photo courtesy of the Nebraska Newspaper Project.)

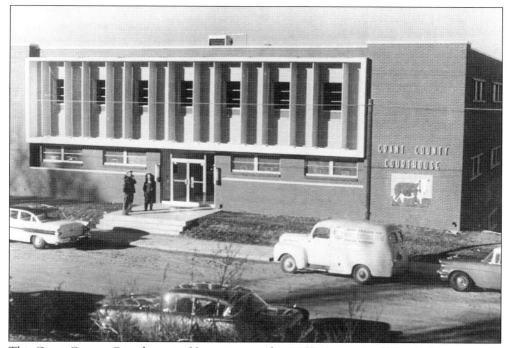

This Grant County Courthouse in Hyannis opened in 1957. A mosaic of Hereford cattle on the right indicates the importance of ranching to the county economy. Like Frontier County, Grant County had been founded by cattlemen. The population of the county is about 800. (Courtesy Nebraska State Historical Society.)

A court battle going to the State Supreme Court held up construction for two years of this Loup County Courthouse, in Taylor. Built of concrete block in 1957 at a cost of $28,500, it is fireproof and has six large rooms. A resolution "commanding all county officials and records be moved to the new courthouse" passed on March 24, 1958. (Courtesy Loup County Clerk.)

This Banner County Courthouse in Harrisburg dates from 1958. Financed by a one-mill tax levy approved in 1949, it serves Harrisburg with a population of less than 100, and the county with a population of less than 1,000. (Courtesy Marshall Tofte and Nebraska Association of County Officials.)

The Brown County Courthouse in Ainsworth, built in 1959 and dedicated in June 1960, replaced the 1888 structure that had gone up in flames. B.H. Backlund of Omaha designed the poured and reinforced concrete building. A monument in the courtyard honors Civil War veterans. A $180,000 20-year bond, insurance proceeds, and a building fund tax financed the $280,000 project. (Courtesy Marshall Tofte and Nebraska Association of County Officials.)

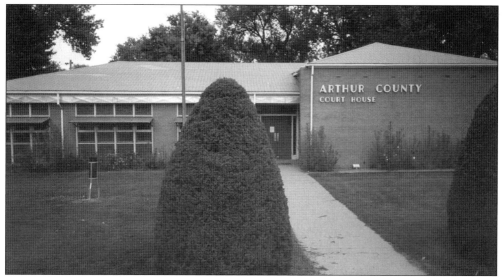

Built at a cost of $53,000, the Arthur County Courthouse in Arthur sat next to the old courthouse and jail, and now serves as a museum. It was designed by Thomas, Benjamin, and Clayton. Dedicated in April 1962, during National Library Week, the building also contains the library. It was an "All Electric" courthouse, a popular feature at the time. Originally built with a flat roof, the pitched roof came later. (Courtesy of Ted Frye, Arthur, Nebraska.)

This two-story Adams County courthouse in Hastings, built in 1963, cost $1.5 million. It is located northeast of the original courthouse, which is now a city parking lot. Building materials include South Dakota marble, aluminum, and glass. Remodeling in 1999 resulted in the removal of an interior fountain. (Courtesy Marshall Tofte and Nebraska Association of County Officials.)

Butler County voters approved a $225,000 bond issue in November 1962. Inheritance tax funds provided an additional $100,000. This Butler County Courthouse, in David City, a modern, single-story structure, was conceived in 1962, erected in 1963, and dedicated in 1964. Regrettably its grand predecessor was razed. (Photo courtesy of Nebraska Newspaper Project.)

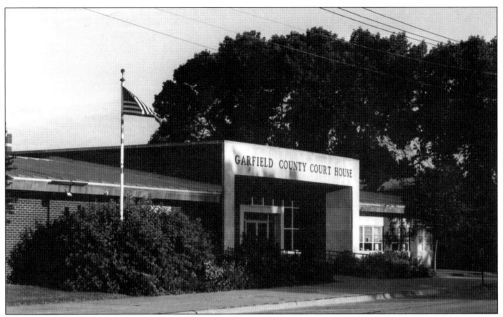

This courthouse in Burwell, Garfield County was financed by $140,000 in bonds. It stands on the site of the old courthouse. Furnishings cost about $19,218. The architects and builders came from Grand Island. The ground floor contains a tile mosaic of the Lady of Justice. The dedication took place on November 11, 1963, Veterans Day. (Courtesy of Erin Koger, Burwell, Nebraska.)

The passage in 1940 of a bond issue did not result in a new Keith County Courthouse in Ogallala. In November 1960, voters approved $250,000 in bonds that resulted in this 18,000 square foot building completed in 1963. Albert LeDioyt, 14 years old when he attended the courthouse opening in 1888, also attended this building's opening in 1963. (Courtesy of the Nebraska Newspaper Project and details provided by Jack Pollock, *Keith County News*.)

The Logan County Courthouse in Stapleton burned down in 1962. Robert L. Murphy of North Platte designed this brick courthouse, built in 1963 and dedicated in August 1964. Ministers from the Assembly of God Church, First United Presbyterian Church, and St. John's Catholic Church offered prayers. (Courtesy Pat Harvey, Logan County Clerk.)

Built between 1964 and 1966, at a cost of $312,000, this Harlan County Courthouse in Alma, designed by Thomas-Benjamin-Clayton of Grand Island replaced the two-story structure built in 1889. Children helped purchase the replica of the Statue of Liberty. A 12 x 18 ft. tile inlay on the floor depicts Harlan County Lake. (Courtesy of Shirley Bailey, Harlan County Clerk.)

This Antelope County Courthouse annex in Neligh built in 1966 sits to the north of the original building. While many county offices moved to the new building, the courthouse remains in the old building. The historic Neligh Mills, powered by the Elkhorn River, opened in 1873. Electricity replaced the river in 1920. The mill ground the last feed in 1969. (Courtesy Marshall Tofte and Nebraska Association of County Officials.)

B.H. Backlund of Omaha designed the Boyd County Courthouse in Butte that was built in 1966. The old jail behind the courthouse is no longer used, and the county has contracted to use the Holt County jail. An attempt in 1989 to locate a low-level nuclear waste facility 2.5 miles west of Butte proved unsuccessful. (Courtesy of Nebraska Newspaper Project.)

This "rambling" fourth Cheyenne County Courthouse in Sidney, built in the winter of 1966-67 around the old building with its basement storage, cost $456,000. The old building was razed in 1968. (Photo Courtesy of Nebraska Newspaper Project.)

The Lancaster County Courthouse in Lincoln was authorized by voters in 1965, designed by two firms, Clark Enersen, and Hemphill, Berg and Dawson, and was completed in 1967. It combined County and City needs, achieving some economy and efficiency over a traditional separation of spheres. Since the Lancaster Correctional Facility was built to the left (south) in 1991 and the County/City Building to the right (north)in 1997, it has been known as the Hall of Justice or the Law Enforcement Center. A recent thorough renovation, designed by two firms Sinclair Hille, and Bahr, Vermeer & Haecker, cost $12 million and included the removal of asbestos.

This is the Lincoln County Courthouse in North Platte, with the 1968 addition to the right. The Sioux Lookout Monument, designed in limestone by sculptor Ervin Goeller of Lincoln in 1931, stood on a hill southeast of North Platte for 66 years. Refurbished in 1998, it now stands on the Lincoln County courthouse grounds. Goeller also has a sculpture at the State Capitol. (Courtesy of Anita R. Childerston, Clerk of Lincoln County District Court.)

This 15,792 square foot Hitchcock County Courthouse in Trenton, completed in July 1969, and costing $275,643 was funded by inheritance taxes and a small 10-year tax levy. The old courthouse was demolished. The vaults were built large enough to serve as working space, a common feature of post-1945 courthouses. The spacious lawn has an underground sprinkler system. (Courtesy of Marshall Tofte and Nebraska Association of County Officials and *Hitchcock County News*.)

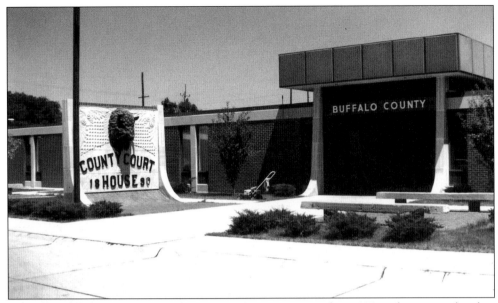

This third Buffalo County Courthouse in Kearney was started in 1973 and was completed in 1974. The Buffalo head was preserved from the late 1880s building. Sale of the county poor farm financed the jail, built in 1959. A detention center was added in 1980. Kearney State College, founded in 1903, became the University of Nebraska at Kearney in 1993. The grand old building was demolished, not without controversy. (Courtesy Marshall Tofte and Nebraska Association of County Officials.)

The 16-level, 6-elevator Omaha-Douglas Civic Center, designed by Leo A. Daly and built by Hawkins Construction opened in 1974. It created new efficiencies by combining county and city functions. The new structure is connected to the 1909–12 courthouse by an enclosed ground level passageway. The main floor contains part of the civil division of the County Court and Small Claims Court. On the lower right is the library, designed by Thomas Kimball and built in 1893. (Photo courtesy of Oliver B. Pollak.)

This Pierce County Courthouse, the third in Pierce, opened in 1975 on the site of the 1890 building, demolished in 1977. The population of Pierce rose from 73 in 1880 to 1,200 in 1910, and stood at 1,774 in 2000. (Photo courtesy of the Nebraska Newspaper Project.)

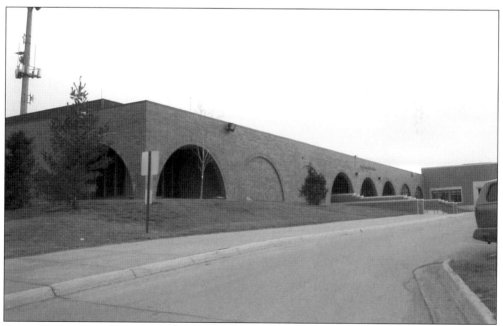

Sarpy County population, by the 1960,s had increased six times and outgrown the 1922 courthouse. Sarpy County was Nebraska's third most populous county but two bond issues in 1962 and 1964 failed to receive voter support. A 1966 levy, selling the county poor farm in 1967, and federal funds for civil defense and law enforcement, funded this current Sarpy County "Hall of Justice" in Papillion, designed by McGaughy, Marshall, McMillan and Backlund, and dedicated in 1975. (Photo courtesy of Oliver B. Pollak.)

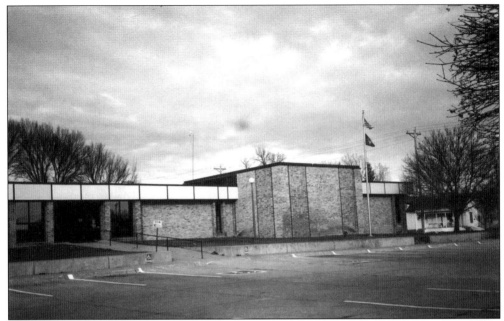

Stanton County Courthouse in Stanton, built on the site of the old courthouse, began construction in 1975. It opened in 1976. One official commented, "Some were sad to see the old courthouse go, but the new one has sure proven to be a nice place to work and it's the most noteworthy building in Stanton." The new courthouse retains the 1876 clock that now sits on a shelf in the Clerk's office, and some "suppose it always will." (Photo courtesy of Carol Armbruster, Stanton County Library.)

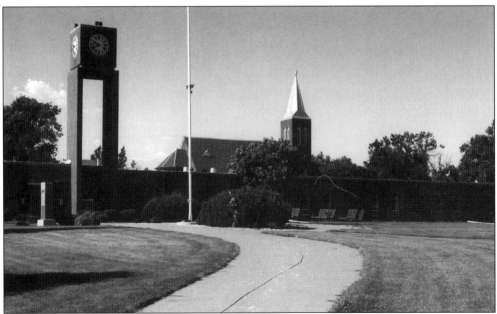

This third Boone County Courthouse in Albion, designed by Glenn Stippich of Lincoln, dedicated on July 5, 1976, cost $363,201. The clock tower incorporates the clock from the 1897 courthouse. (Photograph courtesy of Bob Zoucha, Boone County clerk.)

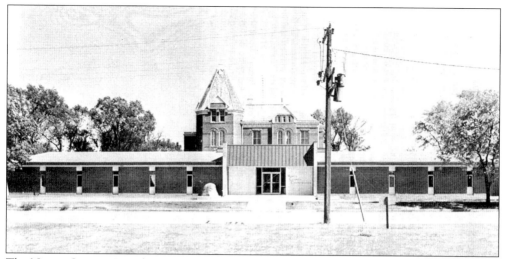

The Nance County Courthouse in Fullerton, designed by George E. Clayton, was dedicated in May 1976, at a cost of $440,000. The old courthouse stands behind the new, and was demolished.

A vote in 1975 to move the Madison County seat from Madison to Norfolk lost 5,560 to 4,277; 60 percent was needed to change the county seat. After much controversy, the current Madison County Courthouse, built one mile north of Madison, was dedicated in 1977. Since then a new jail has been built. The old jail was converted to office space. (Courtesy of Nancy Scheer, Madison County Clerk.)

The York County Courthouse in York, 21 years in the making, was dedicated debt free on October 9, 1980 on the site of the old courthouse. The old courthouse has been used as a "poster child" for the historic loss of buildings that should have been preserved. *Nebraska, Our Towns*, comments, "The off-center 'modern' courthouse, built after its classic predecessor was razed in 1978," is "a subject still too sensitive to be discussed lightly." (Courtesy Marshall Tofte and Nebraska Association of County Officials.)

The fire marshal condemned the Wheeler County Courthouse in 1970. The current Wheeler County Courthouse in Bartlett opened in 1982 just to the west of the old courthouse—now recycled as the County Museum. Nostalgia for the 1920 building led to the comment, "Our new one is not very attractive—but that is my opinion." (Courtesy Marshall Tofte and Nebraska Association of County Officials.)

Seven
THE FEDERAL PRESENCE
COURTHOUSES & POST OFFICES
THE ARCHITECTURE OF MAGNIFICENCE

Federal presence starts with a post office. Housing the District, Appeals, Magistrates and Bankruptcy Courts, as well as the clerks of the Court, library, and holding cells for prisoners, the U.S. Marshall, Internal Revenue Service, Departments of Commerce, Labor, and Transportation, Justice Department, Federal Bureau of Investigation, and military recruiters leads to the erection of a Federal Building.

Design, square footage and luxuriance of accommodations are the subject of lobbying between politicians, civil service, Chambers of Commerce, architects, the building trade, Congress and the General Service Administration. New construction means jobs for architects, earth movers, iron and sheet metal workers, welders, masons, brick layers, electricians, plumbers, glaziers, concrete, roofers, air conditioning and heating providers, landscapers, gardeners, janitors, and security guards.

During the first half of the 20th century the Federal Court comprised eight divisions: Chadron, Grand Island, Hastings, Lincoln, McCook, Norfolk, North Platte and Omaha. In 1955, these divisions reduced were to Lincoln, North Platte and Omaha, the savings were $25,000 per year. Native American tribes maintain their own judicial system such as the tribal court in Winnebago.

Federal buildings–pioneering, innovative and authoritative–become, over time, period pieces. Their federal grandeur, stability, and style provide a distinctive imprint on the cityscape.

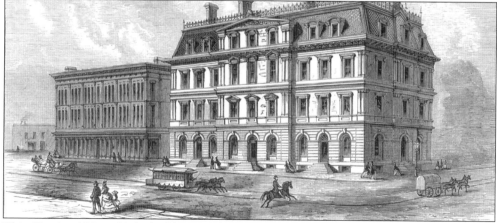

This Omaha 122 x 66 ft. building is characterized by Bruns as a "small federal building" combining courthouse, customs house and post office. Designed by Supervising Architect Alfred B. Mullett, it reflects his Second Empire style preference. Located at Fifteenth and Dodge, and completed in 1874, it cost $300,000. The basement contained the steam heat plant. This 1875 picture includes the Creighton Block on the left. Later referred to as the Army Building, one account records it "was discarded much as one does a worn out suit of clothing."

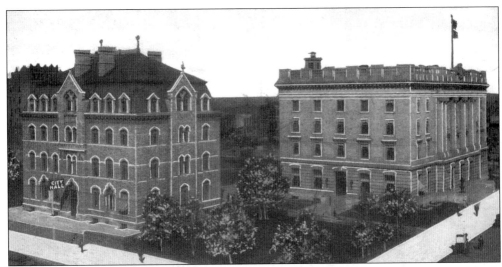

The first Federal Building in Lincoln opened in 1879. Like the pattern in many cities it combined Courthouse and Post Office. Designed in 1874 by Supervising Architect Alfred B. Mullett, during the presidency of Ulysses S. Grant, it was completed during the presidency of Rutherford B. Hayes by supervising Architect William Appleton Potter who preferred, according to Burns, high Victorian Ruskian Gothic. It served as Lincoln City Hall from 1906 to 1969, and continues to meet public needs. On the right is the Federal Courthouse opened in 1907. By 1939, three expansions gave it a horseshoe configuration. The Federal Government vacated the building and turned it over to local government in the early 1970s.

Funding for this Nebraska City post office and courthouse came from the 1885-1886 Congress. Designed in 1886 and completed in 1889, it cost over $100,000. The second floor District Court was never used as such. The supervising architect of this Romanesque Revival-style building was Mifflin Bell. This red brick building, with four corner turrets, currently houses the Farmers Bank and Trust. Other Nebraska post offices noted in *Great American Post Offices* are in Fremont and Scottsbluff. The message on the back proclaims, "We got married this morning at half past ten."

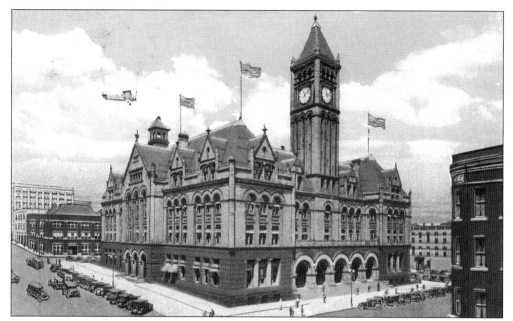

Omaha's growing population prompted requests for a larger Federal and Post Office Building. This Richardsonian structure contained Vermont marble blocks weighing two tons. Conceived in 1889, opened in 1898, and completed in 1906, it cost $1.9 million. John Latenser was the supervising architect. Located between Dodge, Capitol, Sixteenth, and Seventeenth Streets, its stunning design, appreciation of which ranged from "ecstatic to unprintable," made it a dominant piece of downtown architecture. Demolished in 1966, it can be compared to the preserved Old Post Office on Pennsylvania Avenue in Washington D.C.

Congress appropriated $100,000 for a post office and courthouse in Norfolk. This three-story building in the Second Renaissance Revival style, completed in 1904, is attributed to the U.S. Treasury supervising architect James Knox Taylor. The building, a replica of a building in Annapolis, Maryland, was expanded in the 1930s. The post office moved in 1970. Other federal agencies left in 1974. It stood vacant for three years. Converted to private ownership and offices in 1976 it is now called the "McMill" building because of the MCMIII (1903) inscription.

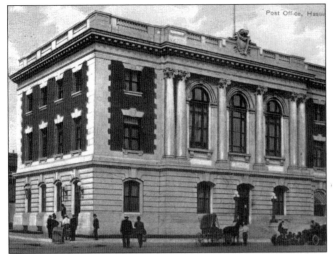

This building, erected for $125,000, opened in Hastings in November 1905, based on the political actions of Charles H. Dietrich of Hastings who served as governor in 1901 and Republican U.S. Senator, 1901-05. It was the "finest structure in the city." The post office occupied the main floor and the court and IRS the second floor. A new post office was built in 1963. This building, demolished in 1971, made way for a savings and loan.

The Grand Island Post Office and Federal Courthouse, sponsored by Senator George Norris, was completed in 1910. A legislative Bill to Regulate Holding United States Courts frequently accompanied legislation funding federal buildings. A west wing was added in 1935. It served as Grand Island's post office until 1968. The building still stands.

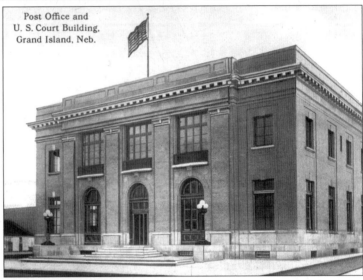

The Post Office and Federal Building in North Platte, was completed in 1913, at a cost of $110,000. It housed the Federal Court, Post Office and Inspector, the IRS, U.S. Navy Recruiting, and the county agricultural agent. The post office moved out in the 1960s. at which time the North Platte Community Junior College used the building. There are three postcards of the building. The differences are the models of the automobiles, the size of the trees, and the last two cards did not have people on the sidewalk.

McCook's favorite son, Senator George Norris, gave the dedication speech at the opening of this impressive $160,000 Federal Building in McCook in 1916. This building, a product of pork-barrel legislation, is in Norris' hometown. The Federal Court moved to North Platte around 1932. The building housed federal agencies including the Soil Conservation Service, the Selective Service, military recruiting offices, and the post office. This building now houses an antique shop.

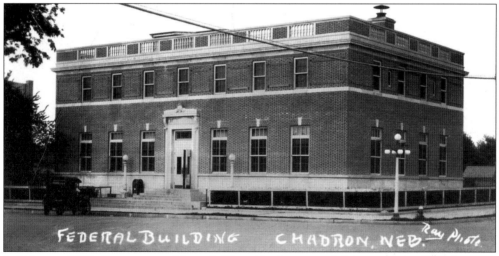

In February 1907, Congressman Moses P. Kincaid telegrammed the postmaster, "Chadron was to be a place for holding federal court." The newspaper headline read, "Kincaid Wins Another Victory—Northwest Nebraska Get In At Last." Following the first session in September 1907, the court adjourned and "the whole Federal court party" went on a hunting trip. Congress appropriated $110,000 for this building in 1913, and the building opened in 1920. The circuit system no longer operates and the building has been used for the Soil Conservation Service, the Selective Service, and of course, as a post office.

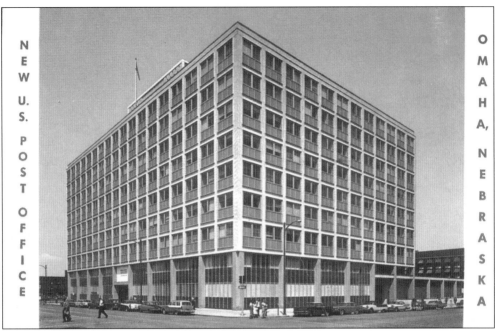

This Federal Building and Post Office in Omaha, built in 1958, housed the District, 8th Circuit and Bankruptcy courts on the eighth and ninth floors. It was renamed the Edward Zorinsky Federal Building after U.S. Senator Edward Zorinsky (1928–87). In color and shape it has some likeness to buildings associated with the Howard Johnson hotel chain. A $41 million three-year renovation program started in 2001. A 14-story Art Deco Federal Building, built in 1933, stands at Fifteenth and Dodge—and is still in use.

The current Federal Building in North Platte, designed by Robert L. Murphy & Henningson, Durham & Richardson, opened in 1964. There are no sitting judges. District and bankruptcy court proceedings are held from time to time by judges from Omaha and Lincoln. (Photo courtesy of Lorrie Barker, GSA, North Platte.)

The Federal Building and Courthouse in Lincoln, dedicated in 1974, is named after Congressman and Federal District Court Judge Robert V. Denney (1916–81). Designed by Leo A. Daly, it is located on Centennial Mall, south of the State Capitol. Opposite on the west side, is the Nebraska State Historical Society Museum. (Photo courtesy of Oliver B. Pollak.)

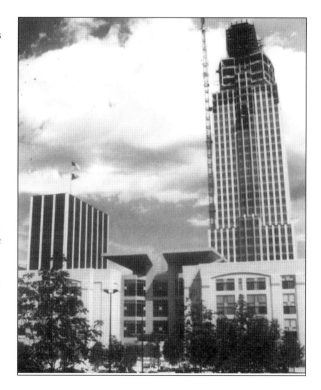

The Roman L. Hruska United States Courthouse in Omaha opened in 2000. Its designer, James Ingo Freed, also designed the U.S. Holocaust Memorial Museum. Freed is a partner with I.M. Pei. It started with a budget in 1993 of about $89 million and was completed, with reduced facilities, at about $55 million. The floor contains the largest solid Great Seal of the United States; its diameter is about 15 feet. Built after the 1995 Oklahoma City bombing, it employs concrete barriers limiting automobile access. On the left is the Double Tree Hotel, previously known as the Red Lion and the Hilton Hotel. The 41-story First National Bank Tower, scheduled for completion in 2002, looms overhead. This building represents a return to the courthouse rather than Federal building model. (Photo courtesy of Oliver B. Pollak.)

Selected Bibliography

Comprehensive accounts of courthouses exist for about 20 states.
County histories and centennial volumes are indispensable for the study of local history. Websites are
a burgeoning resource, in particular the Nebraska State Historical Society, Historical Register, and
various county and city sites. "Google.com" facilitated the gathering of information.

BOOKS AND UNPUBLISHED DISSERTATIONS

Bruns, James H. *Great American Post Offices*. New York: John Wiley, 1997.
Carter, John. *Solomon D. Butcher, Photographing the American Dream*. Lincoln: University of Nebraska Press, 1985.
Fitzpatrick, Lilian L. *Nebraska Place-Names*. Lincoln: University of Nebraska Press, 1960.
Goeldner, Paul K. "Temples of Justice: Nineteenth Century County Courthouses in the Midwest and Texas." Ph.D. diss., Columbia University, 1970.
Hitchcock, Henry R. *Temples of Democracy: The state capitols of the U.S.A.* New York: Harcourt Brace Jovanovich, 1976.
Nebraska, Our Towns. Dallas: Taylor Publishing, 1988–92, 8 volumes.
Olson, James and Naugle, Ronald C. *History of Nebraska*. Lincoln: University of Nebraska Press, 3rd ed. 1997.
Pare, Richard, ed. *Court House, A Photographic Document*. New York: Horizon Press, 1978.
Perkey, Elton A. *Perkey's Nebraska Place Names*. Lincoln: J&L Lee Co., 1995.
Schellenberg, James A. *Conflict Between Communities, American County Seat Wars*. New York: Paragon House Publishers, 1987.
Ward, Denis M. "A Spatial Analysis of County Seat Location in Nebraska: 1854–1930." Ph.D. diss., University of Nebraska, 1973.

ARTICLES, PERIODICALS, AND PAMPHLETS

Abbott, Ned Culbertson. "That Cass County Court House-An Informal History." *Nebraska History* 29 (December 1948): 339–50.
Danker, Donald F., "Columbus, A Territorial Town in the Platte Valley." *Nebraska History* 34 (December 1953): 275–88.
Green, Norma Kidd. "Ghost Counties of Nebraska." *Nebraska History* 43 (December 1962): 253–63.
"Historic Places, The National Register for Nebraska." *Nebraska History* 70 (spring 1989).
Homer, Michael W., "The Territorial Judiciary: An Overview of the Nebraska Experience, 1854–1867." *Nebraska History* 63 (fall 1982): 349–80.
Kilar, Jeremy W. "Courthouse Politics, Loup City, Sherman County, 1887-1891." *Nebraska History* 60 (spring 1979): 36–57.
Luebke, Frederick C. "Time, Place, and Culture in Nebraska History." *Nebraska History* 69 (winter 1988): 150–68.
NACO. "1894-1995, 100 Years of Excellence." *Countyline* 16 (December 1994).
Ohman, Marian M., "PWA and WPA Courthouses in Missouri." *Missouri Historical Review* 46 (January 2002): 93–118.
Olson, Paul A. "Reading Space as Time in Great Plains Recollective Architecture." *Nebraska History* 80 (fall 1999): 109–22.
Schmiedeler, Tom. "Frontier Forms of Iowa's County Seats." *Annals of Iowa* 57 (winter 1997): 1-37.
Shank, Wesley Ivan. "The Demise of the County Courthouse Tower in Iowa: A Study of Early Twentieth-Century Cultural and Architectural Change." *Annals of Iowa* 51 (spring 1992): 337-62.
Van Pelt, Robert, "Stockville, Nebraska: An Inland County Seat Town, about 1900." *Nebraska History* 65 (fall 1984): 327–43.

Index

Bold pagination indicates definitions from the National Register for Nebraska